FORECAST

FORE

TUES WED THUR FRI SAT

CAST

NOZONE X

EDITED BY NICHOLAS BLECHMAN

PRINCETON ARCHITECTURAL PRESS, NEW YORK

Published by
Princeton Architectural Press
37 East Seventh Street
New York, New York 10003

For a free catalog of books, call 1.800.722.6657.
Visit our web site at www.papress.com.

Editor: Clare Jacobson
Special thanks to: Nettie Aljian, Sara Bader, Dorothy Ball, Nicola Bednarek, Janet Behning,
Becca Casbon, Carina Cha, Penny (Yuen Pik) Chu, Russell Fernandez, Pete Fitzpatrick,
Wendy Fuller, Jan Haux, Aileen Kwun, Nancy Eklund Later, Linda Lee, Aaron Lim, Laurie
Manfra, Katharine Myers, Lauren Nelson Packard, Jennifer Thompson, Arnoud Verhaeghe,
Paul Wagner, Joseph Weston, and Deb Wood of Princeton Architectural Press —Kevin C.
Lippert, publisher

Library of Congress Cataloging-in-Publication Data
Blechman, Nicholas.
Forecast / Nicholas Oscar Blechman. — 1st ed.
 p. cm. — (Nozone ; 10)
 ISBN 978-1-56898-793-4 (alk. paper)
 1. Twenty-first century—Forecasts—Miscellanea. 2. Twenty-first century—Forecasts—
Comic books, strips, etc. I. Title.
 CB161.B5495 2008
 303.49—dc22
 2008062199

The human brain invented the concept of a future
and thus we are the only animal that realized we could affect
the future by what we do in the present.
—David Suzuki

TABLE OF CONTENTS

(FAST) FOREWORD

Never before has looking into the future been so complicated or so traumatic. Prophesies, doomsdays, conspiracies, calamities, ice ages, and potential revolutions are everywhere. Wherever you look – from the cover of *Vanity Fair*, to the weird weather outside your window – the messages seem universal: the Earth our children inherit will almost certainly be nothing like the one we currently inhabit. In the spirit of our massive uncertainty, we welcome you to Nozone X, *FORECAST*.

How will global warming affect our economies, our coastlines, our food chains? Which species will survive, and which will become extinct? Will the future be manufactured in Beijing or Bangalore? Will terrorists target LA or DC? Will the future be dark or lite? Hot or cold? Sugar free or caffeinated? Will Iran be the next Iraq? In the next fifty years, will things get a) worse, b) much worse, or c) much much worse? In the next election, will red states become blue, or blue states become red? Has the American dream become the rest of the world's nightmare? Can the U.S. indefinitely sustain a trillion-dollar deficit? Will markets crash or bubbles burst? Will the future be overcast or sunny? Low pressure or high? Inhabitable or not? Or will the answers to these questions be "none of the above" – an array of possibilities not even accessible to our present-bound imaginations.

In Nozone IX, *Empire*, we looked at the networks of power that dominate our political life. In this issue we ask, what are the effects and long-term consequences of our current ways of life? NASA uses some of the world's most powerful computers to predict the future; Nozone uses some of the world's greatest imaginations to bring it to life.

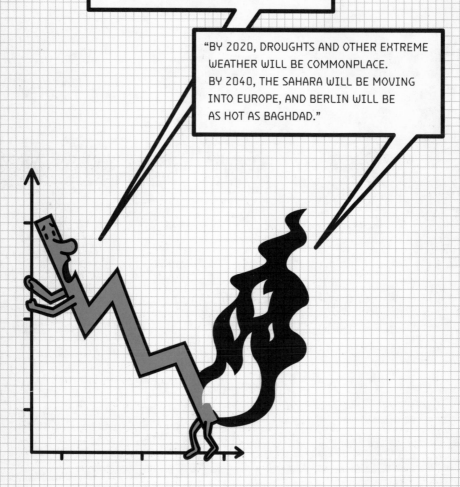

"I Have a GUT Feeling"

THIS CLIMATE OF OURS

WHY THESE OPEN WINTERS AND TEMPERATE SUMMERS?

THE GEOLOGICAL EVIDENCE OF THE ALTERNATE PREVALENCE OF A SEMI-TROPICAL ATMOSPHERE.

Is our climate changing? The succession of temperate Summers and open Winters through several years, culminating last Winter in the almost total failure of the ice crop throughout the valley of the Hudson, makes the question pertinent. The older inhabitants tell us that the Winters are not as cold now as when they were young, and we have all observed a marked diminution of the average cold even in this last decade. Who ever expected to see another importation of ice from Norway after that of ten years ago? Yet, incredible as such a thing would have seemed only a year ago, it actually happened last week.

That this portion of the Northern Hemisphere has been subject to extreme changes of climate in the past is proved by abundant evidence of the most convincing nature. It has been alternately much warmer than it is now and incomparably colder. There was a time when a semi-tropical climate prevailed as far north as Greenland, while at another Manhattan Island was covered with an arctic mantle of ice and snow. Few persons rambling through Central Park or over Washington Heights can have failed to notice the hummocky outlines and worn and scratched surfaces of the rocks. A closer inspection reveals the fact that the scratches, or striæ as they are called by geologists, have a general trend from north to south. Now, these rounded rocks, "sowbacks" they are called in Scotland, and striæ are evidence of glacial action, and they show that the entire State of New-York was at one time covered by a

NEXT GREAT DELUGE FORECAST BY SCIENCE

Melting Polar Ice Caps to Raise the Level of Seas and Flood the Continents

WE still speak of "the Ice Age" as if it belonged to the remote geological past. Geologists have reached the conclusion that there were several ice ages. What is more, the last Ice Age, known as the Quaternary, is only about half over, despite our blistering Summers. "Eternal ice" or "eternal snow" are figments of the poetic imagination. Very slowly the great ice sheets in the Arctic and Antarctic regions are melting and pouring their torrents into the oceans. The earth must inevitably change its aspect and its climate.

How the change is slowly taking place and what the result will be has been considered by such able geologists, physicists and meteorologists as Professor Sir Edgeworth David of the University of Sydney, Australia, Professor Wilhelm Meinardus of Göttingen and a score of others. The latest is Dr. William J. Humphreys of the United States Weather Bureau, who recently addressed the American Meteorological Society on the subject, summarizing old views and modifying them in the light of the information gathered in the Antarctic regions by the Byrd expedition and in Greenland by the ill-fated Professor Alfred Wegener and his companions.

Glacial Sheets Reduced by Half.

The glacial sheets that now cover the North and South Poles were once 12,000,000 square miles in extent— more than one-fifth the present total land area of the globe. In the course of about 700,000 years they have melted down to their present area of about 6,000,000 square miles. The ice on Greenland alone is ten times vaster than the area of the State of New York. Wegener's echo sound-

the sea level will rise fifty feet. Professor Meinardus doubles that estimate. Dr. Humphreys, with the studies of Byrd and Wegener before him, believes that the rise will be 151 feet. Such floods are nothing new, as we see by the marine fossils found on the tops of the Rockies, Andes and other mountain ranges.

The Deluge of the Future.

So, within 30,000 or 40,000 years there will be another deluge. Salt water will sweep over the continents, leaving only the higher land dry. Holland will be inundated. Fish will swim in Buckingham Palace and Westminster Abbey, for most of England will lie beneath the waves. The Desert of Sahara will be a great inland sea. What is now New York will be marked by the upper stories and towers of the taller skyscrapers as they jut out of the water.

In an inundation which would thus change geography and which would be accompanied by a rise in temperature, the climate would return to what is was when dinosaurs roamed the earth and dense jungles of dank, gigantic ferns grew in what are now Pennsylvania and Canada. Palms and alligators would flourish at the poles as they did millions of years ago.

What will become of man if climatic conditions are thus changed? Ice sheets in high latitudes produce strong contrasts in temperatures between the polar and equatorial regions. Winds, storms, weather that changes from day to day are the result. Man flourishes under such conditions. If the torrid zone were to become even more torrid than it is and if what are now frozen tr around the North and South

THE WEEK IN SCIENCE: OUR MELTING NORTH

By WALDEMAR KAEMPFFERT.

New Evidence Supports Geology's View That the Arctic Is Growing Warmer

TWO pieces of evidence were recently presented to substantiate the views held by most geologists that some day there will be no frozen North and that vessels will sail in Arctic seas now imperilled by ice floes. One piece of evidence comes from Greenland, the other from Alaska.

A party of scientists from the University of Michigan, headed by Professor Ralph I. Belknap, found a pile of stones with a very artificial look. At the bottom of the pile was a piece of paper which had been torn from a notebook and which bore a few words signed by the late Professor R. S. Tarr of Cornell and dated 1896. Tarr had gone to Greenland to explore the great Cornell glacier. His note had been deposited at what was then the edge of the glacier, 400 miles north of the Arctic Circle. But the pile found by the Michigan expedition was about three-fifths of a mile further front. There was but [one] conclusion to be drawn. The [glacier] receded.

Turn now to Alaska and look at it through the eyes of Professor Robert F. Griggs of the University of Washington. The forest line is advancing into the tundra or treeless flat country at the rate of one mile in a century. Evidently Alaska's climate is growing warmer. Her trees are the first that have grown in 20,000 years.

Greenland Growing Warmer.

On one point Professor Griggs seemingly disagrees with the scientists from Michigan. He finds that Greenland's climate has been growing increasingly colder for several centuries. Bodies of Norse colonists who settled in Greenland four centuries before Columbus discovered America were buried in ground now icy. The roots of trees long ago frozen to death have pierced many a grave. Who can doubt that Greenland must have had a much milder climate 1,000 years ago than it has now?

The findings of Professors Griggs and Belknap are not actually in conflict. Both scientists are dealing with comparatively short periods. The ice may again creep down upon the spot where Professor Tarr left his note, or it may continue its apparent recession and convert Greenland into a country as hospitable as the Norsemen once found it.

Still in the Ice Age.

Geologists are convinced that we are living in the Quaternary Ice Age, which began about 600,000 or 700,000 years ago and which will continue for thousands more. Although there can be no doubt that the ice will eventually melt at both Poles, it is possible that it will increase in thickness and area before it finally disappears. And what a mass there is to melt! Five million square miles in the Antarctic and 1,000,000 in the North.

The truth is that the earth has passed through several Ice Ages. Those of the past were probably much like that in which the earth is still wrapped. In other words, there were relatively cold and mild periods. Although an ice age may last for 700,000 or 1,000,000 years, it is but a passing phase in the history of the earth. The mild inter-trasts in altitude—high peaks near a coast that drops precipitously into the sea—there we are sure to feel the pushes.

Hold a piece of paper by its opposite edges and slide the two hands toward each other on a table only a fraction of an inch. The paper buckles—folds to form a sort of mountain in the centre. It was thus that the Himalayas and the mountains along South and North American Pacific coasts were pushed up. Nor will the process end for hundreds of thousands of years.

Earthquake Waves.

We live on a crust supposed to be not more than forty-five to sixty miles thick. An eggshell is no thicker relatively. What goes on within the crust or outer shell is the subject of such scientific theorizing. The little knowledge we have has been derived almost entirely from a study of recorded earthquake waves—the most complex waves known. They move up and down like sea waves, and in addition they may have twists. It is easier to predict where than when an earthquake will occur. Moreover, the intensity of a tremor is bound to vary because the earth is not a homogeneous mass. Rock materials are not all of the same kind. Some are dense and some light. Waves would spread out as ever-enlarging spheres in a globe of absolutely uniform material. If they do not, it is because rocks vary.

Geophysicists long ago decided that if light is to be thrown upon earthquakes, and therefore on the structure of the earth's crust, they must experiment as other scientists do—make their own earthquakes under more or less controlled conditions. To be sure, the quakes cannot be of the devastating kind that wipe out whole towns, but they can be formidable enough to be measured by accurate recording instruments. So we find geophysicists exploding charges of dynamite and thus generating waves that travel [through] [rocks] at carefully

Times Wide World.
Dr. L. Don Leet, Director of the Harvard Seismograph Station, Who Has Initiated a New Series of Earthquake Studies.

the new deep vault, where such disturbances are excluded, they reveal periodic tilts which have been linked with high tides along the coast. In fact, they are so sensitive that they will record a rise and fall of only an inch at a distance of 1,500 miles.

With this equipment Dr. Leet and his associates are proceeding to unravel some of the mysteries of earthquakes—seisms, as they call them—and thus to discover something new about the shell that we ineptly call terra firma.

The first problem is to measure the speed of quake waves, which is done by plotting the time of arrival at as many stations as possible. If the speeds are different it is clear that the waves must have encountered resistance that varied. In other words, some rocks permitted the waves to pass more readily than did others. Given a good set of speed records, the seismologist can determine the depth at which the waves traveled. It is thus that the new picture of the earth's crust was formed—a picture of layers of different material, not as regular and sharp as the layers of a cake or the shells of an onion, but still sufficiently well-defined to be identified.

Study of Earth's Crust.

The first effort to arrive at some conception of the crust was made years ago. Rocks were compressed and distorted by measured forces. Thus it became possible to compute the speed at which quake waves would pass through the rocks. If one speed was always associated with one kind of rock and a second and third speed with still other kinds, the geophysicist was clearly in a fair way of deducing from a seismograph record whether an earthquake wave had passed through granite, basalt or the like.

As a matter of fact, in many places the laboratory waves indicated a speed of 5.5 kilometers, or 3.4 miles, a second and in others a speed of 6 kilometers, or 3.7 miles, [a second.] There was some reason

the propagation of waves through the earth's crust, Dr. Leet found other anomalies not so easily explained. It turns out that the speed is by no means a sure indication of the kind of deep rock through which a wave passes. Take limestone, for instance—what the geologist calls a sedimentary rock. A wave will pass through it with a speed so close to that of a wave in granite that no geophysicist worth his salt would dare to say: "This is a limestone wave."

The geophysicist is left hanging uncertainly in the air. He does not know the true composition of the so-called granitic layer of the earth's crust. To discover that is his immediate, perhaps his most pressing, problem. For the time being he must content himself with determining the depths and thicknesses of layers, in itself illuminating work. But as to the nature of deep rocks—there he encounters mystery. It is precisely for the elucidation of this mystery that the subterranean vault at Oak Ridge was fashioned.

* * *

CASTING A HUGE MIRROR.

Complex Processes Required in Making Big Telescope.

THE largest mirror of any astronomical reflecting telescope (100 inches) is that of the Mount Wilson Observatory. McDonald Observatory of the University of Texas is soon to have the second largest if technicians read the signs right and their hopes are fulfilled. For recently a huge pancake of glass was cast which is to become that mirror, a pancake more than a foot in thickness, with a diameter of nearly seven feet and a weight of 5,600 pounds.

Metal and glass though it may be, a great telescope is more sensitive than a baby to changes of temperature and drafts of air. Let the objective be chilled or warmed rapidly and unequally and the images of stars are distorted. Hence the adoption of a special glass—the kind used for baking in the kitchen oven and for laboratory dishes.

Cooling the "Pancake."

The special glass of the McDonald Observatory's mirror was poured at a temperature of about 133 degrees and the temperature then quickly cooled to about 500. The resultant pancake is now slowly cooling in an annealing oven. Over a period of three months the temperature will gradually be reduced. Were it not for this precaution an outer cold crust would be formed while the interior is still more or less plastic. As a result unequal strains would crack the mirror.

When the pancake is cooled it will be shipped to Cleveland to the telescope builders, the Warner & Swasey Company. There the outer edge will first be trimmed off to bring the diameter to eighty inches. Tests will be made for symmetry. If the pancake fails to meet them it will be rejected. Lack of symmetry is an indication of internal strains. If the tests are passed a hole 13½ inches in diameter will be drilled in the centre for the ref[lec-]tion of starlight to an eye[piece] which a highly magnif[ied image] will be formed. Drill[ing]

SCIENCE IN REVIEW

Warmer Climate on the Earth May Be Due To More Carbon Dioxide in the Air

By WALDEMAR KAEMPFFERT

The general warming of the climate that has occurred in the last sixty years has been variously explained. Among the explanations are fluctuations in the amount of energy received from the sun, changes in the amount of volcanic dust in the atmosphere and variations in the average elevation of the continents.

According to a theory which was held half a century ago, variation in the atmosphere's carbon dioxide can account for climatic change. The theory was generally dismissed as inadequate. Dr. Gilbert Plass re-examines it in a paper which he publishes in the American Scientist and in which he summarizes conclusions that he reached after a study made with the support of the Office of Naval Research. To him the carbon dioxide theory stands up, though it may take another century of observation and measurement of temperature to confirm it

Abundant Gases

In considering the theory, Dr. Plass reminds us that the most abundant gases in the atmosphere are nitrogen and oxygen. There is also a little argon. These cannot absorb much of the heat radiated by the earth after it has been warmed by the sun. If they could,

starches) causes a large loss of carbon dioxide, but the balance is restored by processes of respiration and decay of plants and animals.

Despite nature's way of maintaining the balance of gases the amount of carbon dioxide in the atmosphere is being artificially increased as we burn coal, oil and wood for industrial purposes. This was first pointed out by Dr. G. S. Callendar about seven years ago. Dr. Plass develops the implications.

Generated by Man

Today more carbon dioxide is being generated by man's technological processes than by volcanoes, geysers and hot springs. Every century man is increasing the carbon dioxide content of the atmosphere by 30 per cent—that is, at the rate of 1.1° C. in a century. It may be a chance coincidence that the average temperature of the world since 1900 has risen by about this rate. But the possibility that man had a hand in the rise cannot be ignored.

Whatever the cause of the warming of the earth may be there is no doubt in Dr. Plass' mind that we must reckon with more and more industrially generated carbon dioxide. "In a few centuries," he warns, "the amount of carbon dioxide released into the atmosphere

YEAR 2025 FORECASTS STATE THAT TWO THIRDS OF
THE WORLD POPULATION WILL BE WITHOUT SAFE DRINKING
WATER AND BASIC SANITATION SERVICES.

2025

	CENTER OF WORLD POWER	WORLD POPULATION	MAIN SOURCE OF FUEL	CHIEF MODE OF TRANSPORTION	MOST COMMON HUMAN HABITAT
2010	UNITED STATES OF AMERICA	6,838,220,136	OIL	CAR	HOUSE
2030	CHINA	8,295,925,812	VEGETABLE OIL	MOPED	APARTMENT
2050	UNITED STATES OF CHINA	9,404,296,384	NUCLEAR	NUCLEAR MOPED	CUBBYHOLE
2070	BIGGEST ISLAND AVAILABLE	1,456	STICKS	ICE SKATES	IGLOO
2090	UNITED ISLANDS	5,489	DEFROSTED TREES	ROCKET ICE SKATES	IGLOO CONDO
3010	OFF-WORLD COLONY M3.2	0	SOLAR	ROCKET SHIPS	SPACE HUT

DOMINANT WORLD FAITH	DOMINANT LANGUAGE	MOST POPULAR ART FORM	MOST POPULAR GADGET	AVERAGE LIFE EXPECTANCY	MOST COMMON DISEASE
CHRISTIAN FUNDAMENTALISM	ENGLISH ('sup Dude? TTYL!)	PHONECAST	SMART PHONE	80	COMMON COLD
BUDDHISM	MANDARIN (嘻戲)	HOLOGRAM STORY	VERY SMART PHONE	85	COMMON COLD
BUDDHISM	MANDARINGLISH (嘻 TTYL!)	DREAM PROJECTION	PHONE IMPLANT	90	COMMON COLD
FUNDAMENTALISM	TOO COLD TO CHAT	CAVE DRAWING	CLUB	06 (6)	COMMON COLD
SURVIVALISM	ICEAGEISH	POST-CAVE DRAWING	SMART CLUB	65	COMMON COLD
TOTAL ESCAPISM	SILENCE	FUTURISM	JET PACK	400	COMMON COLD

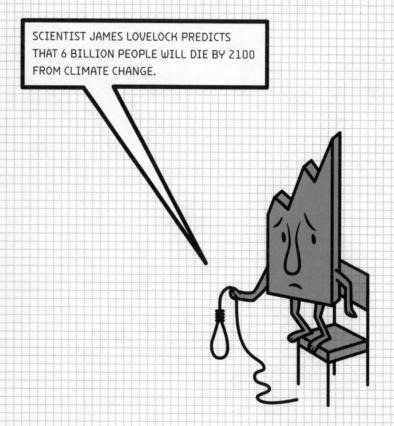

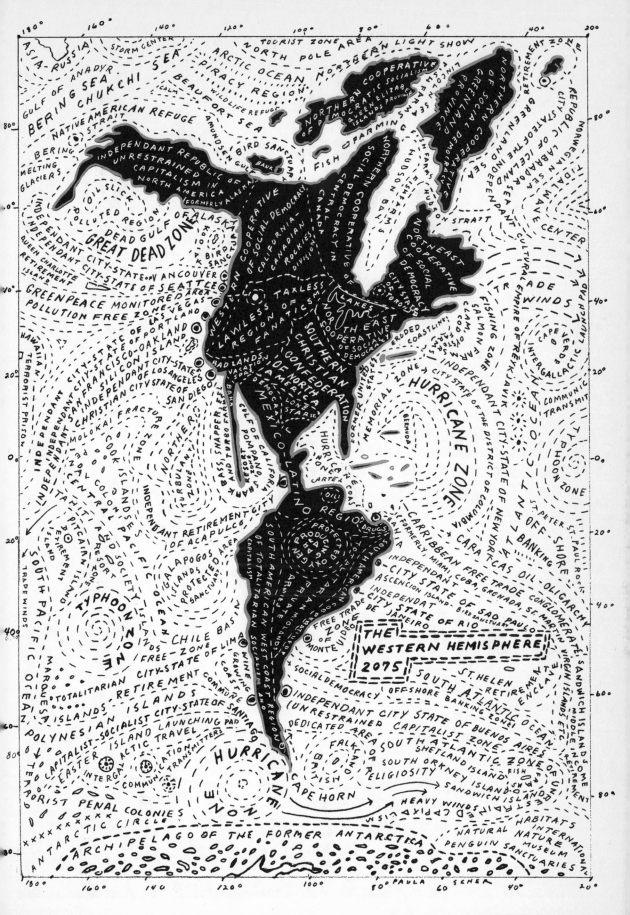

Oil change: ~ 2107

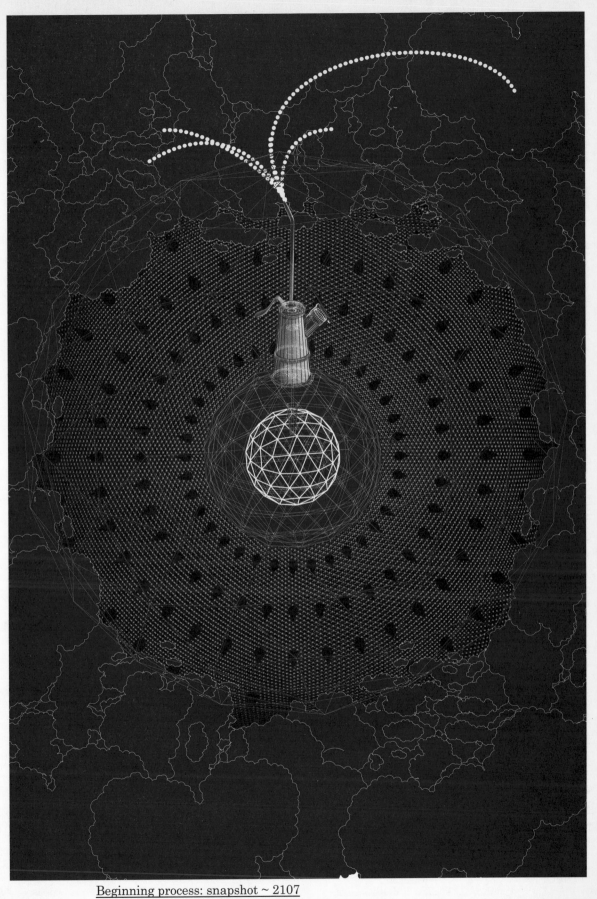

<u>Beginning process: snapshot ~ 2107</u>

During a polar flyby on May 2107, the radar X-Ray CR took a photo of the Big Rain of 2107 – one of the largest oil changes ever seen on this planet.

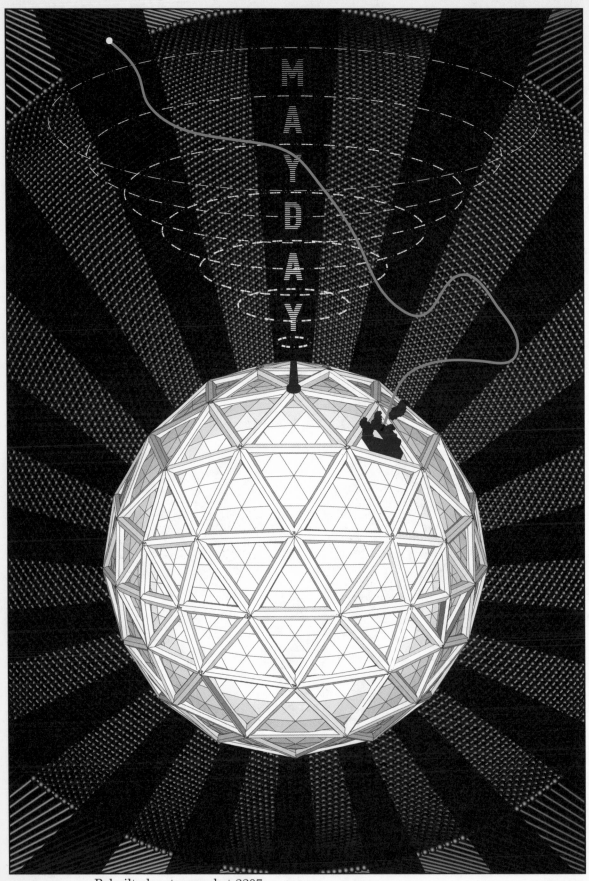

Rebuilt planet: snapshot 2207

X-Ray CR provides its first image of the new planet.

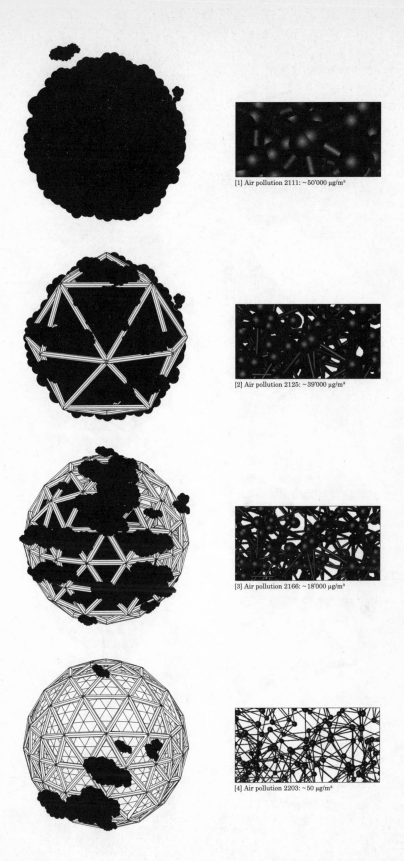

[1] Air pollution 2111: ~50'000 µg/m³

[2] Air pollution 2125: ~39'000 µg/m³

[3] Air pollution 2166: ~18'000 µg/m³

[4] Air pollution 2203: ~50 µg/m³

Big Baaaang: snapshots 2111–2203

2111: dirty black clouds; 2125: 1st step of the rebuilt planet; 2166: 2nd step; 2203: new planet.

NUISANCE

MAJORBULSHI

TOXICO

CHRYSES

MIA

INFERNO

Nobail

LYINCOLIN

SARS

bs

Volkanicage

SUNBURN

Carrion

CheneysPhukups

Catastrophe

Quitter Senate

HANDOFF

Castrati

PANIC

Gitmo

maNia

Fuchs
&
Felix

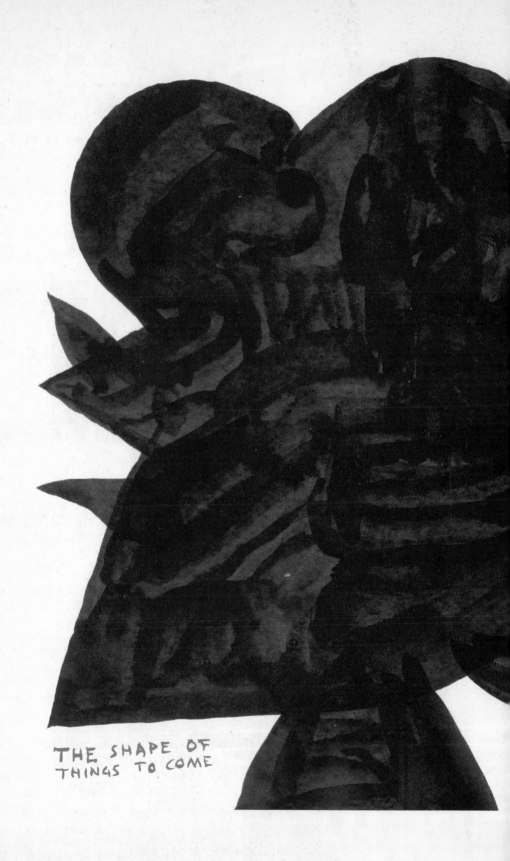

THE SHAPE OF
THINGS TO COME

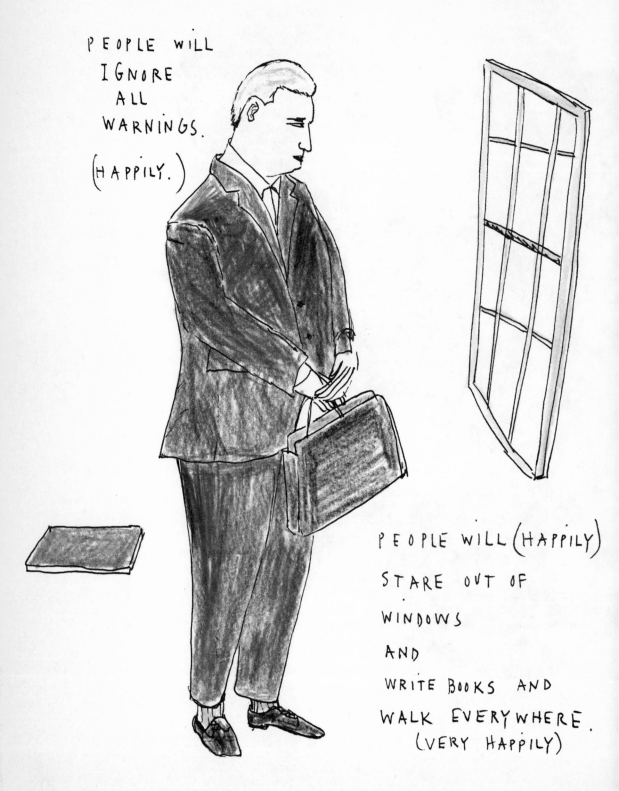

PEOPLE WILL STOP SPEAKING (HAPPILY)
(EXCEPT TO THEIR PETS)

PEOPLE WILL
IGNORE
ALL
WARNINGS.

(HAPPILY.)

PEOPLE WILL (HAPPILY)
STARE OUT OF
WINDOWS
AND
WRITE BOOKS AND
WALK EVERYWHERE.
(VERY HAPPILY)

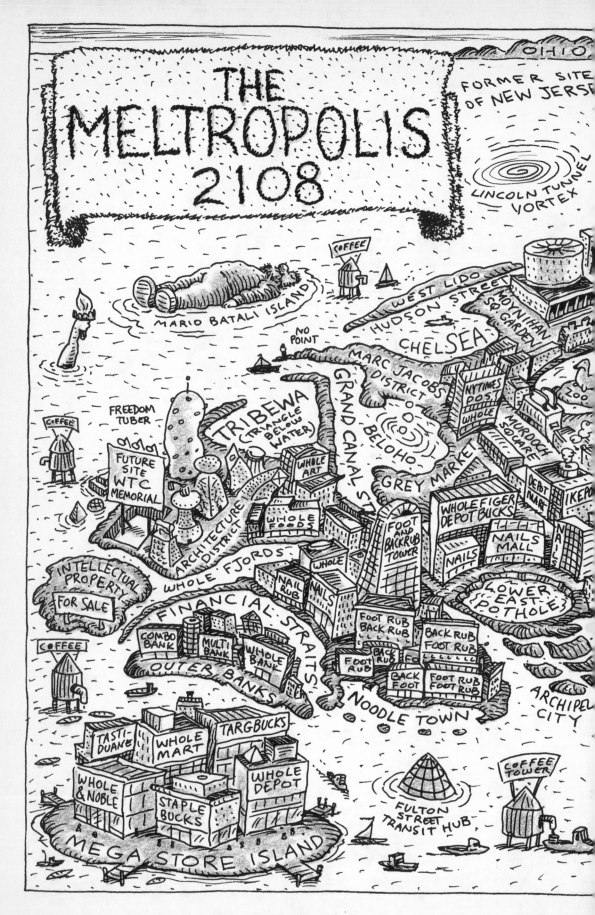

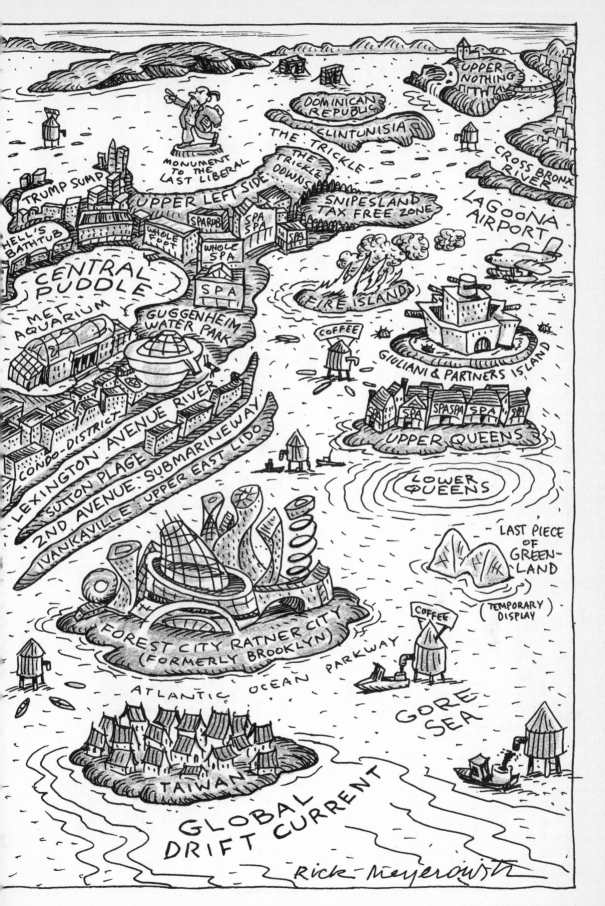

Ever wonder where your carbon footprint will be 100 years from now?

ANSWER THE CALL!

Take 3 minutes to get your Future Impact score and get started on creating your personal plan! Be part of the solution to Nozone's 100–year forecast.

LET'S GET CARBON-ATED

START HERE:

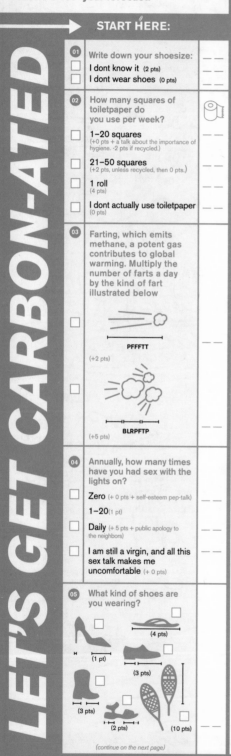

01 Write down your shoesize: _ _
☐ I dont know it (2 pts) _ _
☐ I dont wear shoes (0 pts) _ _

02 How many squares of toiletpaper do you use per week?
☐ 1–20 squares _ _
(+0 pts + a talk about the importance of hygiene. -2 pts if recycled.)
☐ 21–50 squares _ _
(+2 pts, unless recycled, then 0 pts.)
☐ 1 roll _ _
(4 pts)
☐ I dont actually use toiletpaper
(0 pts)

03 Farting, which emits methane, a potent gas contributes to global warming. Multiply the number of farts a day by the kind of fart illustrated below
☐
PFFFTT
(+2 pts) _ _
☐
BLRPFTP
(+5 pts) _ _

04 Annually, how many times have you had sex with the lights on?
☐ **Zero** (+ 0 pts + self-esteem pep-talk) _ _
1–20 (1 pt)
☐ **Daily** (+ 5 pts + public apology to the neighbors) _ _
☐ I am still a virgin, and all this sex talk makes me uncomfortable (+ 0 pts) _ _

05 What kind of shoes are you wearing?
☐ (4 pts)
☐ (1 pt)
☐ (3 pts)
☐ (3 pts)
☐ (2 pts)
☐ (10 pts)
(continue on the next page)

INSTRUCTIONS:

Please take your left shoe off. Place the book on the floor with this spread open. Place both of your feet onto the footprints on this page.

[LEFT]

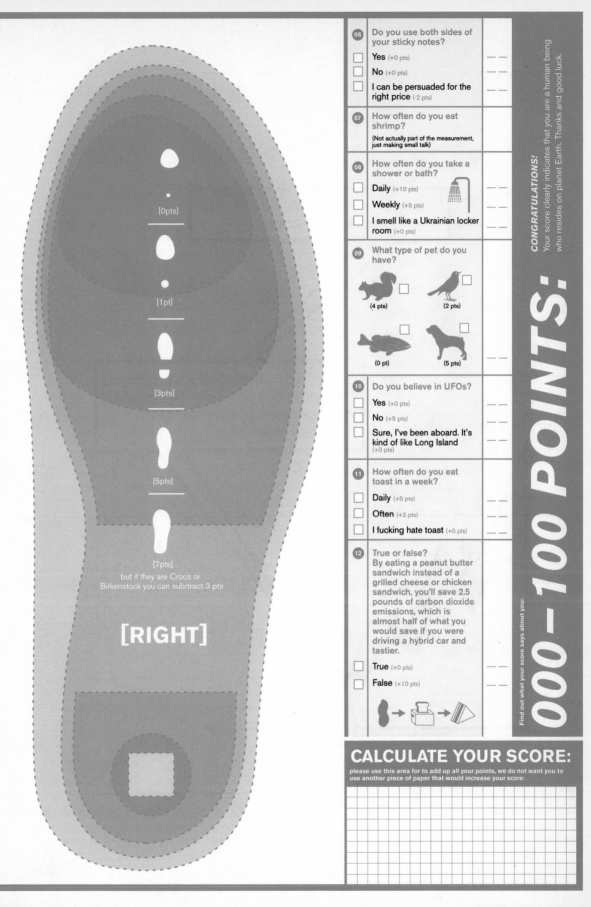

[0pts]

[1pt]

[3pts]

[5pts]

[7pts]
but if they are Crocs or Birkenstock you can subtract 3 pts

[RIGHT]

06 Do you use both sides of your sticky notes?

☐ Yes (+0 pts)

☐ No (+0 pts)

☐ I can be persuaded for the right price (-2 pts)

07 How often do you eat shrimp?

(Not actually part of the measurement, just making small talk)

08 How often do you take a shower or bath?

☐ Daily (+10 pts)

☐ Weekly (+5 pts)

☐ I smell like a Ukrainian locker room (+0 pts)

09 What type of pet do you have?

☐ (4 pts) ☐ (2 pts)

☐ (0 pt) ☐ (5 pts)

10 Do you believe in UFOs?

☐ Yes (+0 pts)

☐ No (+5 pts)

☐ Sure, I've been aboard. It's kind of like Long Island (+0 pts)

11 How often do you eat toast in a week?

☐ Daily (+5 pts)

☐ Often (+2 pts)

☐ I fucking hate toast (+0 pts)

12 True or false?
By eating a peanut butter sandwich instead of a grilled cheese or chicken sandwich, you'll save 2.5 pounds of carbon dioxide emissions, which is almost half of what you would save if you were driving a hybrid car and tastier.

☐ True (+0 pts)

☐ False (+10 pts)

Find out what your score says about you:

000–100 POINTS:

CONGRATULATIONS!
Your score clearly indicates that you are a human being who resides on planet Earth. Thanks and good luck.

CALCULATE YOUR SCORE:

please use this area for to add up all your points, we do not want you to use another piece of paper that would increase your score:

FUTURE HOMELESS

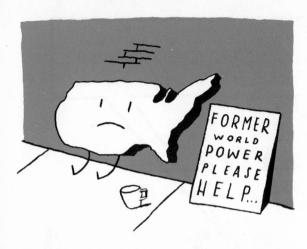

More Weird Weather Coming Your Way

SAT	SUN	MON	TUE	WED
HIGH 75 LOW 68	**HIGH -6 LOW -7**	**HIGH 80 LOW 66**	**HIGH 99 LOW 89**	**HIGH 155 LOW 153**
Unseasonably cool. Mostly cloudy with scattered showers and isolated thunder.	Frigid. Overcast. Large chunks of polar icecap may fall in afternoon. Wear helmet.	Pleasantly warm. Mid-level clouds of insecticide. Dead lobster alert along local beaches.	Muggy. Slimy. Thick fog, mostly toxic arriving by evening. Visibility: 3 inches Breathability: Nil	No discernable ozone layer. Blistering sun. Fire everywhere. Stay inside your SUV.

Salt Lake City

160's

FEAR

A ONE YEAR INVENTORY:

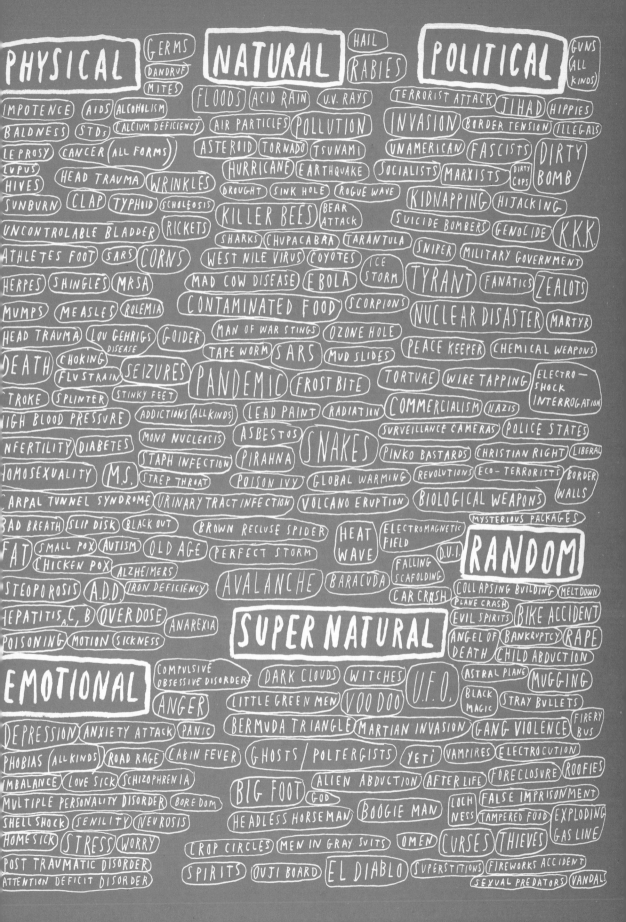

CONSCIOUSNESS
AND
CATASTROPHE

...th Kolbert, *New Yorker* writer and author of *Field Notes*
...strophe (2006), interviewed by Elizabeth Amon in Larchmont,
...York, September 2007. Illustrations by Knickerbocker.

...y from the title of your book,
...t the climate change we
...going and about to experience
...fe threatening. How imminent
...part of your prediction?
...ur lifetime? Or the lifetime of
...?

...nate enough to interview the top
...ut I am not a climatologist, so nothing
...is my conclusion, because I have no
...astrophe could take many different
...c on that topic. It is a catastrophe
...may be a catastrophe for our own
...as strictly meant to wake people up
...much we can do to avert catastrophe
...in terms of climate change. Partly
...y many things have been set in motion
...ends to a certain extent where this
...—it depends on what we do. So that's
...say. Certainly if we continue on our
...and we look at the predictions, then
...ntury, which will be way beyond our
...ldren's, but not our grandchildren's),
...etty dicey. And once again, I'm not
...ook at the models. If we continue on
...e will reach triple the carbon dioxide
...by the end of the century. When you
...ngs look pretty awful.

...ome to write about this for

It seemed important when I first began reading about it. My interest dates back to 1988—when the coverage exploded and then continued over the years as I watched nothing happen. There was Kyoto and nothing happened. [The Kyoto Protocol was an international treaty assigning mandatory emissions limits for the reduction of greenhouse gas emission, drafted in 1997.] And it seemed like, what the hell is going on? Why aren't people taking this seriously? It seemed really strange to me, so I was trying to figure out why it was that way—and I still feel that way. Why aren't people taking this more seriously? Now I'm happy to say that a lot of people's consciousness has changed. A lot of things have conspired, like the fact that it's getting hotter and hotter, to awaken people. But it's still staggering to me, absolutely staggering that we've done absolutely nothing. We may have a consciousness now but if you look at actual CO_2 output from the U.S., we might as well not have one because it really hasn't made the slightest bit of difference.

The public's lack of interest is true of a lot of things
though, like corruption around the funding for
the Iraq war, which involves people's tax money—
but they don't seem to care.

Absolutely, it's not unique. We seem anesthetized. What's different is that with climate change you have a problem that is truly life threatening. As bad as the war in Iraq is, and I don't want to minimize that, it's still confined to the people who are directly participating in it. With climate change we seem to be at the hinge of history, and if we are fortunate enough to have descendants

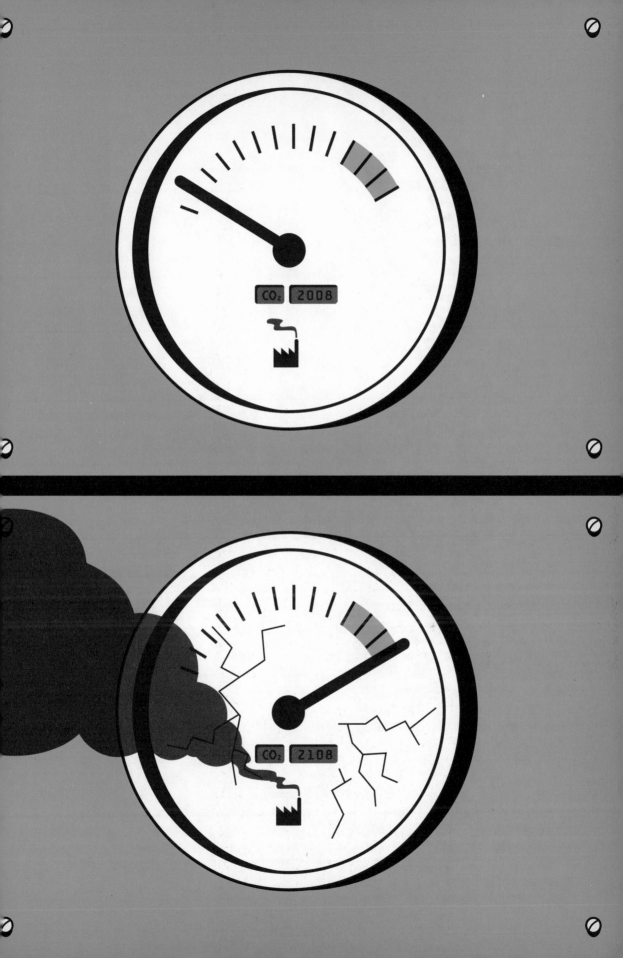

who have the leisure to look back on us, they will judge us harshly.

In your book, you compile evidence of climate change in a variety of ways and geographic locations, from an Alaskan Inupiat village that is forced to move from its ancestral island home because higher temperatures are threatening the destruction of their town, to the northern expansion of European butterflies into Scotland, to the disappearance of Costa Rica's golden toad. Was there one story or experience, more than any others, that particularly brought home the seriousness of global warming?

What convinced me was when someone told me about this tiny town in Alaska that starts the book. Why is that? Because it's people, and it's always people that we're interested in. It really struck me that they were living on an island that was disappearing out from under them. The metaphorical and actual significance of it seemed overwhelming. Now it's become this pilgrimage for everybody interested in climate change and it's helped raise awareness, but it hasn't helped the poor people get a congressional appropriation, which is what they want and need to get off this island and relocate, which is very, very expensive.

You write that if we were to hold emissions steady for the next half century, much steeper cuts would be needed in the following half century to keep CO_2 concentrations from impossibly high levels. Assuming there is a shift in public and political opinion in the U.S. that enables us to reduce emissions, will that be enough to stop the climate change?

The big question, and the question on which I am agnostic, certainly the evidence is not heartening, is when have you reached this threshold called dangerous anthropogenic interference (DAI)? [A point at which the rising greenhouse gas levels mean that climate change will result in unavoidable disaster.] The melting of the Arctic ice—let's just take that as an example because it's a pretty understandable one, though there are many other things that can be used as a measure. Have we set that in motion? The frank answer is we don't know. There's just a huge time lag. John Holdren [the Director of the Program on Science, Technology, and Public Policy at the John F. Kennedy School of Government as well as Professor of Environmental Science and Public Policy at the Department of Earth and Planetary Sciences at Harvard University] has said we should not talk about the

danger being in the future. We are in the danger zone. Now how deep into the danger zone are we? We don't know. I think it's quite possible that we have passed over some important thresholds and possible that we could still avoid it. The really depressing thing is that we're not making any efforts to avoid it.

What about the increasing problems in China and other developing nations that American policies can't control?

China—it's always out there and it's huge. I don't want to minimize that it is absolutely at some level the heart of the matter, and it's going to be used in this country as an excuse to do nothing—not that we even feel we need an excuse. I think increasingly global pressure will be on the U.S. It's just an outrage what's happening in this country. Much of the rest of the industrialized world is ready to move forward and acknowledge that the industrialized world has to take the lead. So it really raises huge questions about global equity and gets to the heart of the matter. How do you divvy up limited resources? And the atmosphere turns out to be a limited resource. That being said, I think if the U.S. figured out a way to do this, other nations would figure out a way to do this, because it would be desirable. Why do people want to buy cars? We all have cars and now everyone in the world has cars because, you know, they're fun, they're nice, they're convenient, they're useful. So if we developed these technologies, these wonderful technologies then other people would also adopt them because they'd be cheaper or better.

The Chinese are not morons. They are also facing huge climate risks, I mean fantastic climate risks. They realize that, and they are trying to negotiate in their own way this horrible trade-off between life style, rising standard of living (which all of their people want, understandably) and humongous climate risks of having half the country turn to desert. They're taking the short term way out, "Let's just burn a lot of coal," and that's exactly what we've done. People talk about—and once again I'm not advocating any technology—CO_2 capture and storage. That is definitely feasible—you just have to do it, and it costs money right now. But if we develop the technologies that bring down the cost and prove that it is feasible, then maybe the Chinese would follow. Certainly we can't expect the Chinese to do it before we do—it's just laughably insane.

So do you see the Dutch, with their preparations for "giving back land to the water by abandoning rural

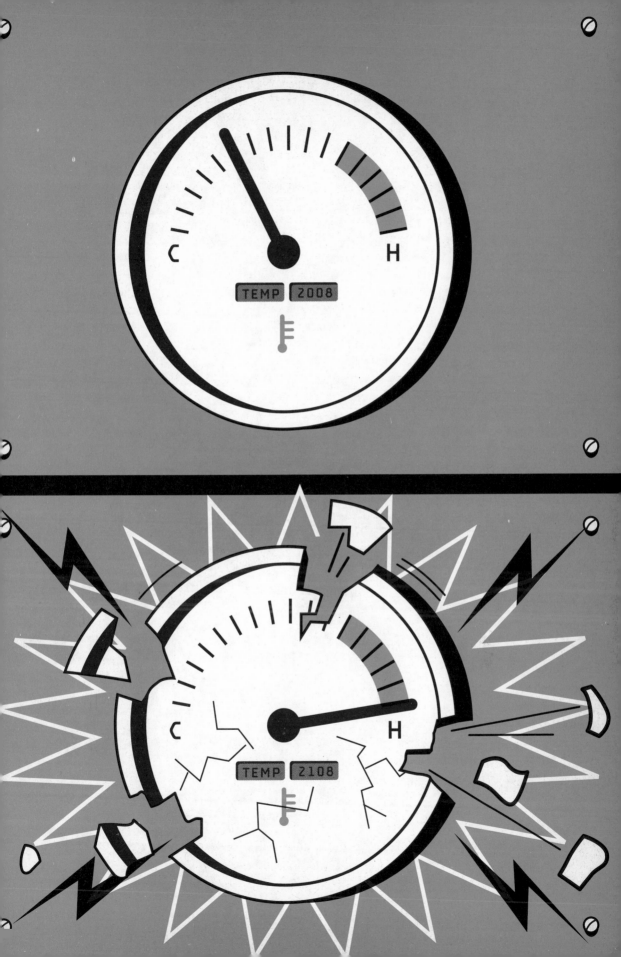

Those two are often presented as if they are in opposition. Are you going to work on adaptation or are you going to work on mitigation? The fact of the matter is we're going to have to do both. There is a lot of climate change—we made a big commitment that we can't really alter without radical steps like geoengineering, which people will increasingly be talking about. These are not trivial changes; these are changes of a sort that the world has not seen for tens of millions of years. So we will be increasingly talking about how do we counteract our own folly here by a potentially different kind of folly. Those are hugely complicated questions—I don't know how we'll ever resolve them, and we don't have that much time to resolve them. So while we sit around and discuss them, many things will have already irrevocably changed. So we're going to have to adapt to a certain amount of climate change or try these really radical geoengineering schemes. And we're also going to have to do something—the thing that people don't seem to quite get is that you keep pouring CO_2 into the air, your climate keeps changing, it doesn't stop changing. So as someone put it to me—a really smart guy, David Rind [a researcher at NASA's Goddard Institute for Space Studies]—what are we adapting to? The climate in 2020? The climate in 2040? The climate in 2060? Those are not the same things and you can already see that. You can already see that that's the case. So you need to do both. You absolutely need to do both. If you'd like the climate to stabilize eventually, if you think that's a useful thing—then you are going to take steps so that the concentrations are stable, and that requires us to basically emit very little CO_2. The actual natural world can only absorb a fraction of the CO_2 that we put out every year, a small fraction. So if you want concentrations to stay steady, you can only be putting out that small fraction.

There are those who argue that humans have found ingenious responses to large problems in the past—plastic has replaced metals in many cases, or the holes in the ozone layer were stopped as chlorofluoro-carbons were phased out. Or, as one of your subjects points out, humankind has made choices like ending slavery and child labor that were not in our economic interests. Do you think that, when pressed, the

I'm agnostic about this. I don't have a strong clear view of the future. It's very nice to say we're going to come up with something, but the sad fact is we have known that burning fossil fuels is a problem since we started to burn them. We haven't changed that. Why? Because oil is extremely energy rich, extremely energy dense, it fits in your gas tank and it turns out to be a miracle substance. It's nice to say, "Let's find something else" and lord knows we need to, but it doesn't turn out to be that simple. So I hope, I sincerely hope that we can.

But this notion that there's something out there. I think there's a real fog about what energy is and how much energy we use. If you go through your day and think about what you're doing at every moment and how much energy you use when you start your day—it adds up really, really fast. And then imagine where you are going to get this. I have solar panels on my house now, for example, and I know exactly how much they put out and it's been a real revelation. They are providing only a part of the electricity my family is using. If I had many more of them, and if I had a plug-in car and a huge stack full of batteries and all those things, I could no generate all the energy that my family is using. And we're not counting all the energy of the stuff coming into my house, like food. With the energy out there—once again I'm not an energy expert—what are we talking about as an alternative? There's always fusion over the horizon. There's a big fusion project going on. It's starting up, but under the most optimistic scenarios, that won't produce power for another fifty years. We have fallen into this mode of saying, "Oh, it will appear," or "It will come." We are very clever people. Lord knows, we are very clever people. But the world has limitations. We have transcended some of those limits—we got to the Moon. But at a certain point reality does limit you.

In your book, you note the success of Al Gore's film An Inconvenient Truth. *Based on the public response, Gore pronounced himself "optimistic" that the U.S. would "respond in time." Are you optimistic?*

I'm not optimistic. When you look at it realistically there's very little to be optimistic about. That's what everybody says, and that's what you're almost obligated to say because why encourage people to just throw in the towel? And as I said before, I think we're constitutionally very optimistic. We're just programmed to reproduce

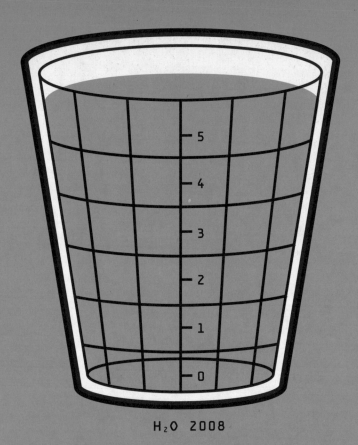

H₂O 2008

H₂O 2108

programmed to believe in a future. If we didn't believe in a future there wouldn't be six and a half billion of us, that's for sure. And if you look at the Europeans, they are not even reproducing to keep pace with their own mortality, so they sort of have lost faith in the future. I totally identify with them, even though I have three kids (a thirteen-year-old and twin nine-year-olds).

Have there been incidents, experiences, or other information that you've discovered since writing the book that has had an impact on your thinking about the topic?

Tragically no. I wish there were. If anything, things have accelerated. In the afterword to the paperback I write about certain things that have occurred more quickly than people were predicting in the book. The sea ice is a very good example of that. In the original I wrote that the year 2080 was when it was predicted that the Arctic Ocean could be ice-free in summer, and that now seems wildly optimistic. Now some models are predicting the Artic Ocean will be ice free in summer by 2040—it's a horrifying statistic. As I say, we have a global consciousness and yet not. It's like "Uh, Arctic sea ice, it's a long way away. It's so cold up there—who cares?" Wow. Really—it will affect us, sitting right here. The absence of Artic sea ice is just huge.

We just got in the figures for 2007, have you seen them? We hit a new record at the end of the melt season, which was a week ago [the end of September 2007]. If you go on the website of something called the National Snow and Ice Data Center, the pictures are just horrific. [http://nsidc.org/news/press/2007_seaiceminimum/20071001_pressrelease.html.] Just horrific. I think they say we've lost six Californias. There's a Northwest Passage open now, for example.

Have you changed the way you live because of your work on climate change?

Those kinds of questions are really complicated and hard. Certainly it makes me hideously aware. Have I radically changed my life as a result? No, but I do all those things, the top ten things you can do to cut down on your CO_2 emissions. I do all of them. My kids have learned to turn off the power strip when they turn off the TV. But I'm still emitting way too much CO_2.

You conclude the book with the sentence, "It may seem impossible to imagine that a technologically advanced society could choose, in essence, to destroy itself, but that is what we are now in the process of doing." Is there no hope for the future?

That's what we're doing. We haven't consciously made that choice because we've been unconscious. But that's the choice that's before us, and a non-choice is still a choice. Al Gore had this great line in a *Rolling Stone* interview last year. He was talking about all the really horrible ways we're already addicted to oil, because we are completely addicted to liquid fuel. Gore said, "a junkie will find veins in his toes." We will find ways to get oil to feed this appetite that we know is very, very destructive.

The thing that's key is that, in this curious and bizarre way that we haven't really faced up to, we are in control of the future. I use a phrase—it's Paul Crutzen's, a Nobel Prize winner—we're in the anthropocene. We're on this Earth that is dominated by human activity. We can choose to acknowledge that or not, but it is fact. And the fact is that we are altering the world on a geological scale—changes that in the natural world would take a hundred million years, we're going to accomplish in a century. We are truly at this extraordinary moment where we will determine the fate of the planet for many, many, many generations. So we can choose to not acknowledge it, but we are still doing it. Many people have commented that our consciousness has never caught up with our technological skill, and we don't unfortunately have much time to bring those two things together, but we really ought to. Many people would say, "Wow, it's an unbelievably fascinating time to be alive," and that's true. As horrifying as many things are it's unbelievably fascinating to see what we are going to do. I wish I saw signs of our facing up to this responsibility. I don't so far, but I don't think it's impossible either.

So my own optimism, my own pessimism—it's kind of irrelevant. The point I would hope and want to convey to people—and many people have said this before—we can deny we're in control, but we are in control. You can use it for better—I don't want to say we can improve the natural world, but we can acknowledge it and face up to it and try to act like adults, or we can party on until the party's over, as they say.

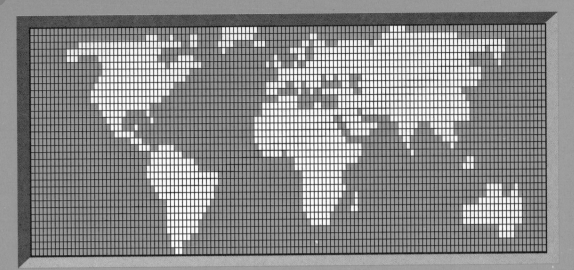

SEA LEVELS 2008

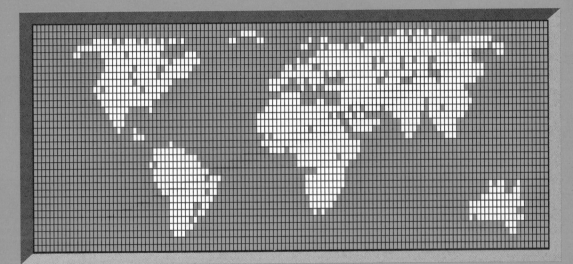

SEA LEVELS 2108

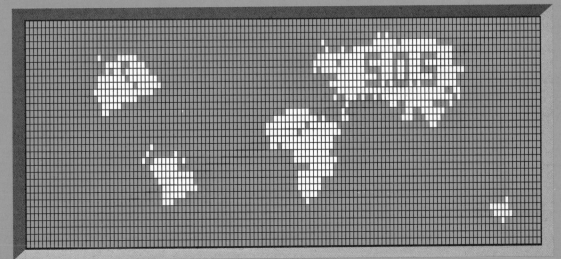

SEA LEVELS 2208

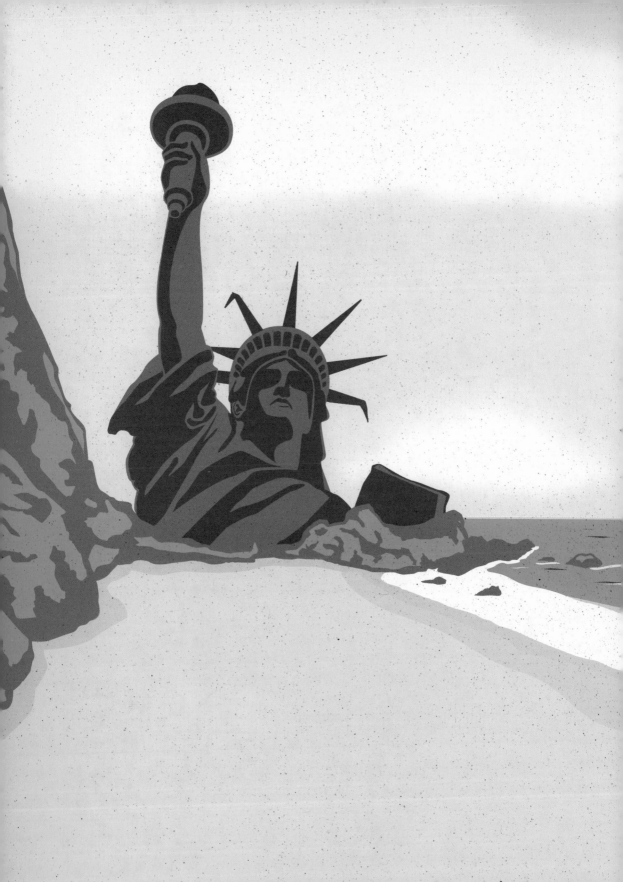

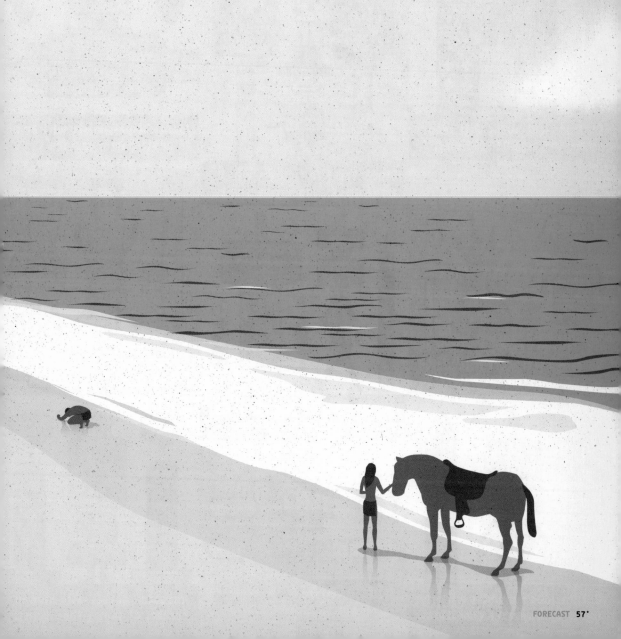

THE TOBOT PROPHECY

Henning Wagenbreth • tobot illustration systems

Uneducated serial killers will practice in the rain forests.

Gene-manipulated school girls will glow in aeroplanes.

Retired light bulbs will read poems in baseball stadiums.

Plastic police officers will discover child labor factories.

Identical pessimists will bomb in adult horror movies.

Burning bartenders will arrive in European coastal waters.

Blue-eyed fire fighters will serve drinks under fingernails.

Armed women will catch flies in the middle of explosions.

Unconscious mummies will live under bad weather conditions.

Sad salt shakers will complain on abandoned planets.

Unbeaten angels will hide in corners of snowy landscapes.

Swiss cowboys will commit suicide in botanic gardens.

Political swimmers will practice in hot water buckets.

Shrinking heroes will read newspapers in FBI helicopters.

Undercover pitbulls will be elected into art academies.

Manipulated prisoners will send parcels to the moon.

Handsome nightingales will paint thunderstorm clouds.

Lost transistor radios will cry on top of refrigerators.

First-class giants will live in cheap Japanese hotels.

Well-dressed bacteria will get married in cooking pots.

One-handed gangsters will occupy forbidden national zones.

Smelly oranges will smuggle cocaine in raw chicken eggs.

Chocolate traffic signs will sing during funeral ceremonies.

"THE REVIVAL OF RELIGION IS MIXED UP WITH POLITICAL CONFLICTS, INCLUDING AN INTENSIFYING STRUGGLE OVER THE EARTH'S SHRINKING RESERVES OF NATURAL RESOURCES; BUT THERE CAN BE NO DOUBT THAT RELIGION IS ONCE AGAIN A POWER IN ITS OWN RIGHT."

Dirty · Father · Harry
Private · Celibate · Dick

ONE NEED ONLY LOOK AROUND TO SEE THE SIGNS

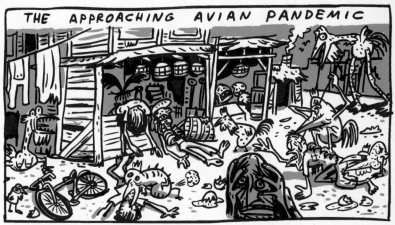

THE APPROACHING AVIAN PANDEMIC

CATASTROPHIC CLIMATE SHIFTS

HOLY WAR

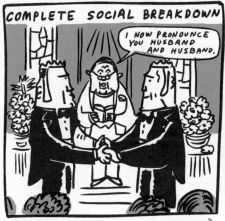

COMPLETE SOCIAL BREAKDOWN

I NOW PRONOUNCE YOU HUSBAND AND HUSBAND.

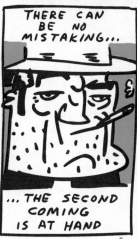

THERE CAN BE NO MISTAKING...

...THE SECOND COMING IS AT HAND

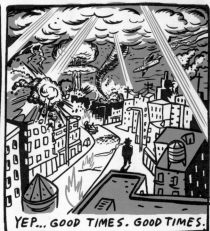

YEP... GOOD TIMES. GOOD TIMES.

2007 MARK MAREK

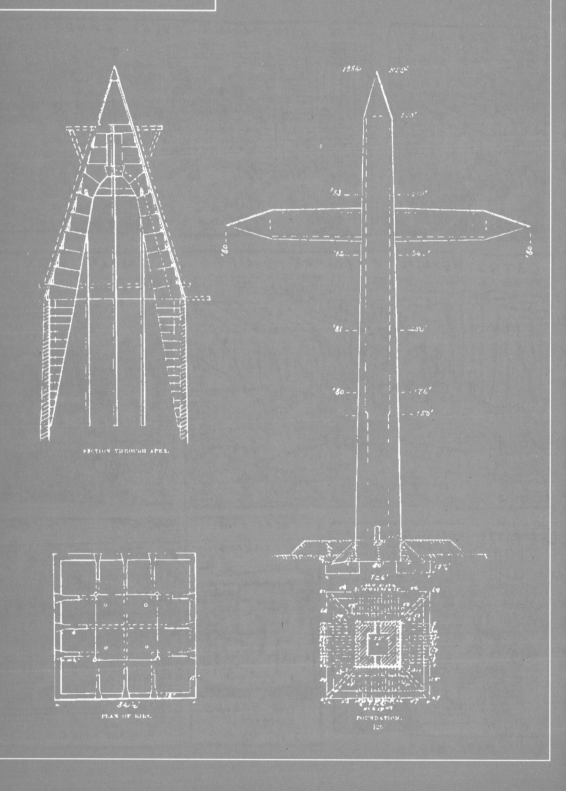

SECTION THROUGH APEX.

PLAN OF RIBS.

FOUNDATION.

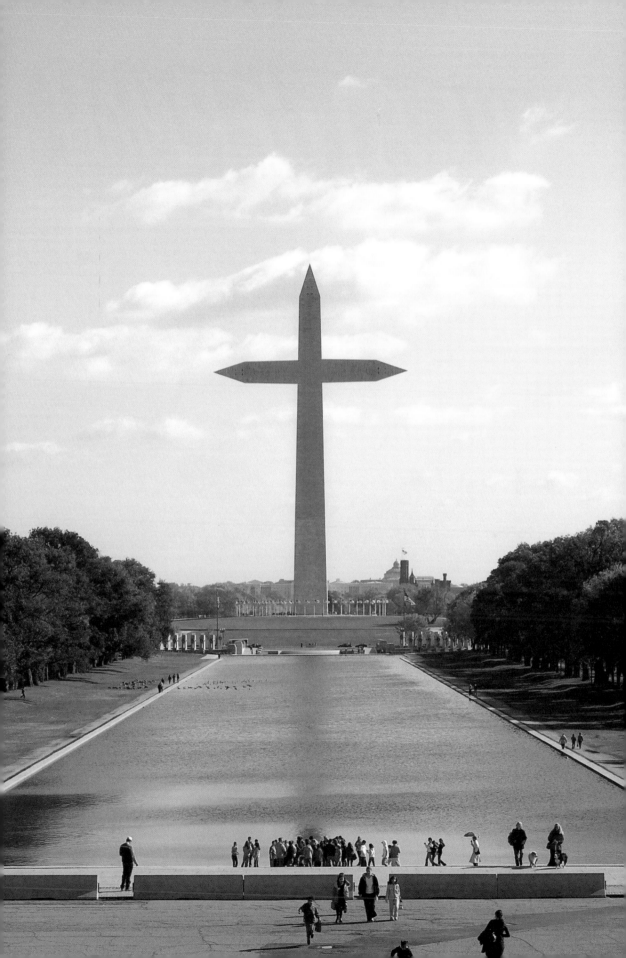

WHERE THE WIND HOWLS AND THE LIGHTENING CRACKS -- THERE WILL BE

WEATHERMAN

BY ERIK T. "LOBROW" JOHNSON

...SO BREAK OUT THOSE UMBRELLAS FOLKS! THIS IS CHANCE O'CLOUD, CHANNEL FOUR'S "ROVING WEATHERMAN" LIVE FROM SHADY OAK HEIGHTS!

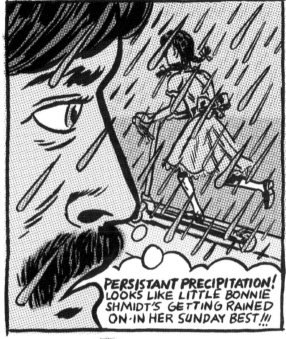

PERSISTANT PRECIPITATION! LOOKS LIKE LITTLE BONNIE SHMIDT'S GETTING RAINED ON · IN HER SUNDAY BEST !!!

CAMERAMAN'S GONE, SO I'LL JUST DUCK IN THE NEWS 4 VAN...

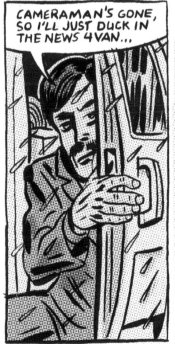

AND RE-EMERGE AS WEATHERMAN !!!

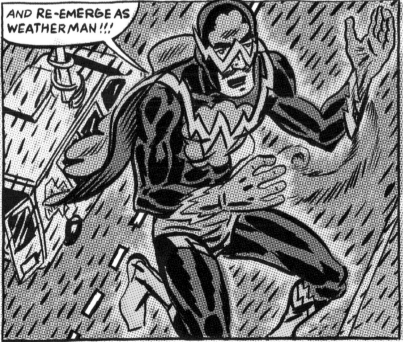

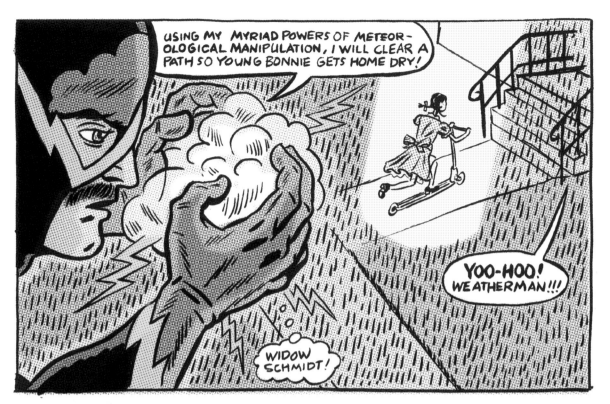

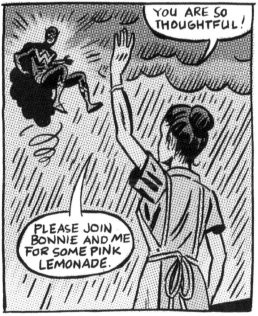

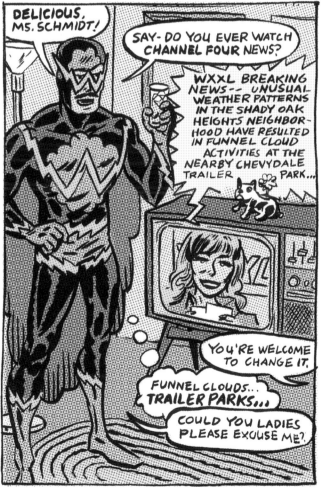

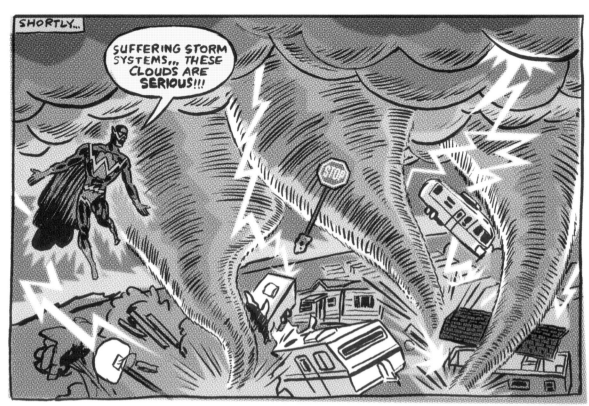

SHORTLY...

SUFFERING STORM SYSTEMS... THESE CLOUDS ARE SERIOUS!!!

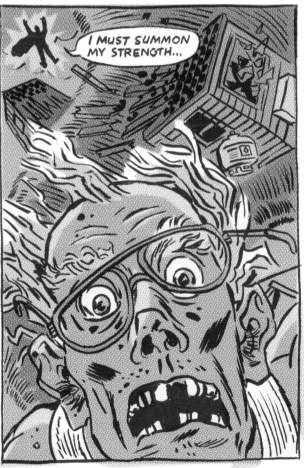

I MUST SUMMON MY STRENGTH...

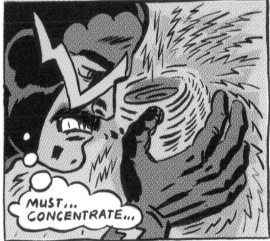

MUST... CONCENTRATE...

AAAAARGH!!!

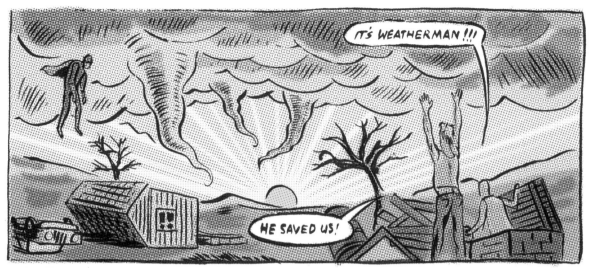

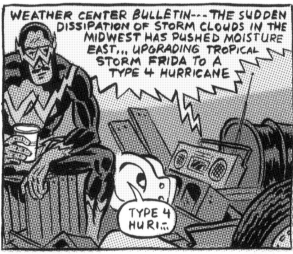

MUST...GET... ABOVE...

EXACERBATING EPICENTERS!!!

THIS IS GOING TO HURT...

FOCUS... FOCUS...

AAAAAARRRRRGH!

UUUUGHHH!

KOF! KOF!

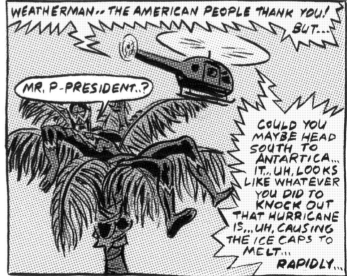

WEATHERMAN... THE AMERICAN PEOPLE THANK YOU! BUT...

MR. P-PRESIDENT...?

COULD YOU MAYBE HEAD SOUTH TO ANTARTICA... IT... UH, LOOKS LIKE WHATEVER YOU DID TO KNOCK OUT THAT HURRICANE IS...UH, CAUSING THE ICE CAPS TO MELT... RAPIDLY...

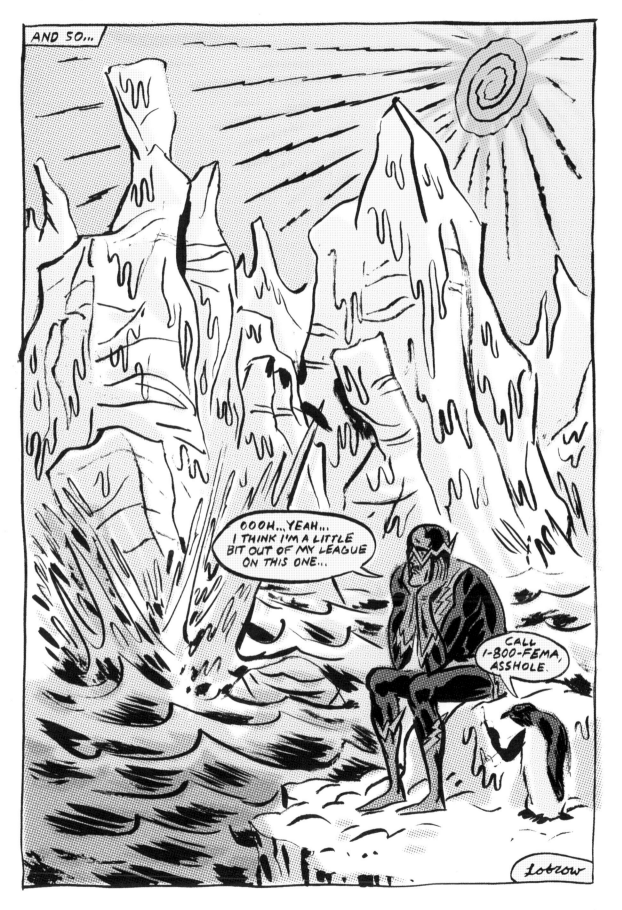

NOZONE SURVIVAL KIT

BY JESSE GORDON/PHOTOS BY TONY CENICOLA

In the past, after a disaster has struck, local officials and relief workers have come to the scene and tried to rescue survivors. They have done so with varying degrees of success. In some cases, victims have been saved because they packed the appropriate disaster supplies ahead of time and were able to extend their lives until relief workers arrived.

Sadly, in the future, experts predict that disasters will be of a magnitude so vast and horrific that relief work will not be possible. We at Nozone believe that the packing of certain supplies is still a good idea — if not to extend, then at least to improve the precious time that one has left. It is therefore in a spirit of both realism and positivity that we have designed the NOZONE SURVIVAL KIT.

FOOD + DRINK

1. WATER: Store water in non-breakable plastic containers. Store one gallon of water per person per day.

2. JUNK FOOD & CANDY: Twinkies, Snickers, foie gras etc. The higher the cholesterol and calorie counts the better. Everything you've ever craved. Go for broke. It's now or never.

3. WINE: Store at least one bottle of wine per person per day. Keep in mind that in a disaster situation, the sharing of wine is extremely rare.

1. GAS MASK: Probably useless in the modern environmental disaster, but a stylish, retro-flavored accessory to any emergency kit.

2. BUG SPRAY: Experts predict that as the world changes beyond recognition, bugs of all kinds will thrive. Don't let them bother you. And don't get all PC about aerosols either—it's too late for that.

3. WATER WINGS: Handy in a flash flood, tsunami, or just for a giggle.

LUCKY

CONTINUOUS

SPRAYER

FIRST
AID

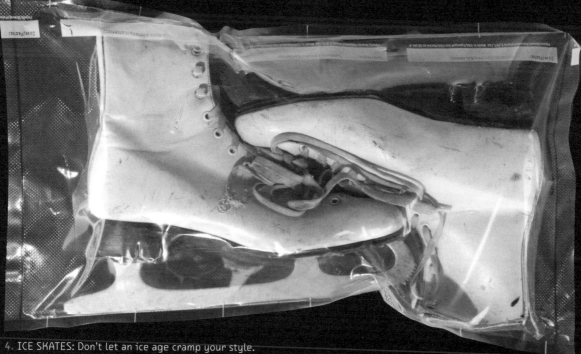

4. ICE SKATES: Don't let an ice age cramp your style.

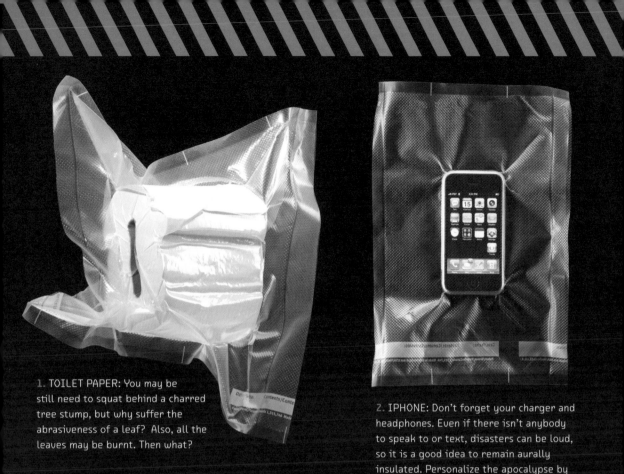

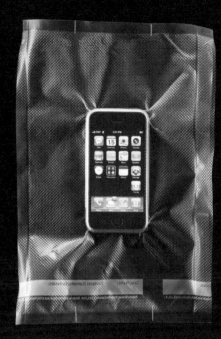

1. TOILET PAPER: You may be still need to squat behind a charred tree stump, but why suffer the abrasiveness of a leaf? Also, all the leaves may be burnt. Then what?

2. IPHONE: Don't forget your charger and headphones. Even if there isn't anybody to speak to or text, disasters can be loud, so it is a good idea to remain aurally insulated. Personalize the apocalypse by adding your own soundtrack.

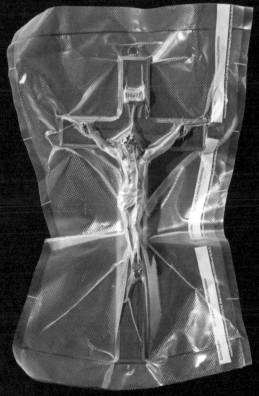

3. CRUCIFIX: If it is the Rapture, you don't want to be left behind.

4. GAS: Three barrels per person per day, depending on what you drive. Don't let your lifestyle slip—you're an American after all!

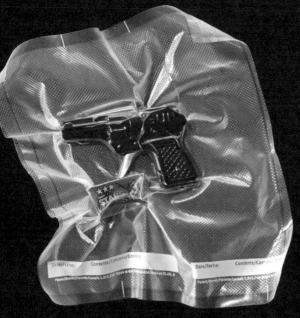

5. HANDGUN: Avoid problems with other survivors. Remember: not everyone will be as well supplied as you are.

6. PORNO: Now is not the time to get all prudish. Birth control not required either.

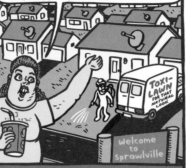
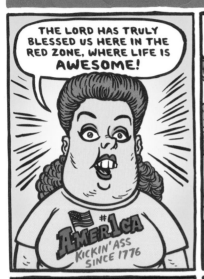
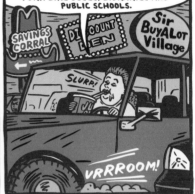
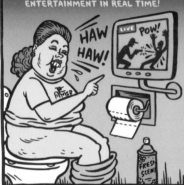

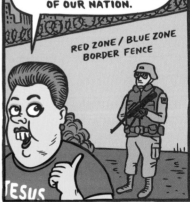

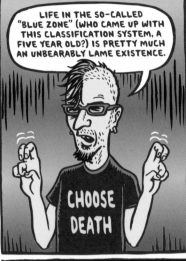

LIFE IN THE SO-CALLED "BLUE ZONE" (WHO CAME UP WITH THIS CLASSIFICATION SYSTEM, A FIVE YEAR OLD?) IS PRETTY MUCH AN UNBEARABLY LAME EXISTENCE.

CHOOSE DEATH

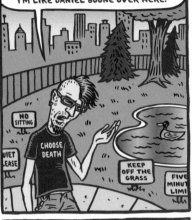

BLUE SPACE IS DIVIDED BETWEEN HIGH-DENSITY URBAN AREAS AND THESE FAUX-RUSTIC "NATURE" AREAS PROTECTED BY THE GOVERNMENT. GEE, WOW, LOOK AT ME I'M LIKE DANIEL BOONE OVER HERE.

NO SITTING

QUIET PLEASE

CHOOSE DEATH

KEEP OFF THE GRASS

FIVE MINUTE LIMIT

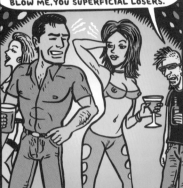

THREE CHEERS FOR THE SINGLES SCENE! PLASTIC SURGERY HAS GOTTEN SO ADVANCED AND OBLIGATORY THAT EVERY DAY TRADER AND TRUST FUND BABY NOW LOOKS LIKE A MODEL. PLUS, IT'S SOCIALLY ACCEPTABLE TO WEAR CLOTHING THAT IS NOT ONLY SKIMPY, BUT TRANSLUCENT AS WELL. BLOW ME, YOU SUPERFICIAL LOSERS.

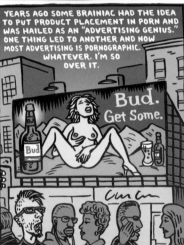

YEARS AGO SOME BRAINIAC HAD THE IDEA TO PUT PRODUCT PLACEMENT IN PORN AND WAS HAILED AS AN "ADVERTISING GENIUS." ONE THING LED TO ANOTHER AND NOW MOST ADVERTISING IS PORNOGRAPHIC. WHATEVER. I'M SO OVER IT.

Bud. Get Some.

Bud

CHOOSE

THEY FINALLY LEGALIZED MARIJUANA. GREAT. NOW WITH THE POT TAX AND ALL THE GROWERS REGULATIONS IT'S LIKE FIVE TIMES AS EXPENSIVE AS IT USED TO BE. FUCKERS.

LIQUOR ISLAND

POT MART

THAI STICK

HOMESTYLE HAND-ROLLED SPLIFFS

BROWNIE SALE

OPEN

CHOOSE DEATH

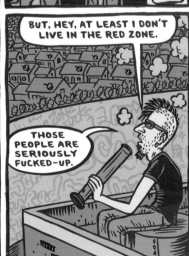

AS FOR OUR ESTEEMED LEADERS, NOWADAYS YOU CAN'T EVEN THINK OF GETTING ELECTED UNLESS YOU'RE A BEAUTIFUL CELEBRITY. IN FACT, MOST POLITICIANS ARE JUST ACTORS THE PARTIES HIRE AS PUPPETS TO DO THEIR BIDDING. INSPIRING, HUH? SOMEDAY YOU, TOO, COULD PLAY THE ROLE OF THE PRESIDENT ON TV.

VOTE

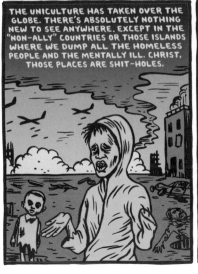

THE UNICULTURE HAS TAKEN OVER THE GLOBE. THERE'S ABSOLUTELY NOTHING NEW TO SEE ANYWHERE, EXCEPT IN THE "NON-ALLY" COUNTRIES OR THOSE ISLANDS WHERE WE DUMP ALL THE HOMELESS PEOPLE AND THE MENTALLY ILL. CHRIST, THOSE PLACES ARE SHIT-HOLES.

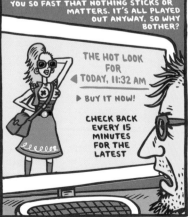

ART, THEATER, MUSIC – THESE THINGS HAVE FLOURISHED ... IF BY "FLOURISHED" YOU MEAN "HAVE BEEN COMMODIFIED INTO MEANINGLESS PRODUCT CHURNED OUT AT A BREAKNECK PACE." IT ALL BOMBARDS YOU SO FAST THAT NOTHING STICKS OR MATTERS. IT'S ALL PLAYED OUT ANYWAY, SO WHY BOTHER?

THE HOT LOOK FOR TODAY, 11:32 AM

▶ BUY IT NOW!

CHECK BACK EVERY 15 MINUTES FOR THE LATEST

BUT, HEY, AT LEAST I DON'T LIVE IN THE RED ZONE.

THOSE PEOPLE ARE SERIOUSLY FUCKED-UP.

مدينـــــة المستقبل

THE CITY
OF THE FUTURE

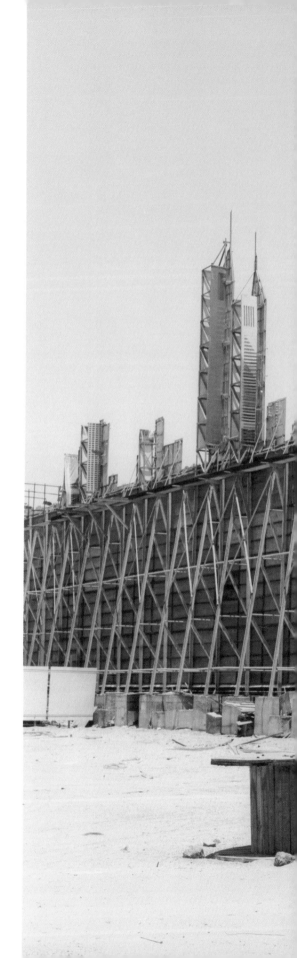

BY JASON FULFORD

DUBAI HARDLY ACKNOWLEDGES ITS PAST EXCEPT
as one half of a sensational "before and after" shot. And
the present seems entirely devoted to the future. Like
Brasilia in 1958, the entire city is going up at once. The
framed watercolors on the wall of my hotel breakfast
room depict brand-new additions to the Dubai skyline.
The present is the future in Dubai. His Highness Shaikh
Mohammad bin Rashid Al Maktoum, Vice-President and
Prime Minister of the UAE and Ruler of Dubai, is the
overseer of this development boom, but unlike Brasilia,
there is no master plan. It was evident at this year's
Arabian Travel Market in Dubai that private developers
seem to be competing for the title of Most Outrageous.
Projects in development include a twenty-square-mile
archipelago of reclaimed land in the Persian Gulf called
"The World," a life-size replica of Mount Rushmore, a
skyscraper where each floor rotates independently, and
the Burj Dubai, which will eventually stand over twice
as tall as the Empire State Building.

In a moment of philosophical wonder, I asked Nader
Abdullah, engineer of the World, how one builds a
foundation in the sand. He looked at me with a poker
face and said that there are over fifty different types
of foundations for sand; that it depends on the density
of the sand and the type of structure you want to
build. As an American, it's easy to visit Dubai seeking
metaphors and hidden meanings, but the truth is much
more direct.

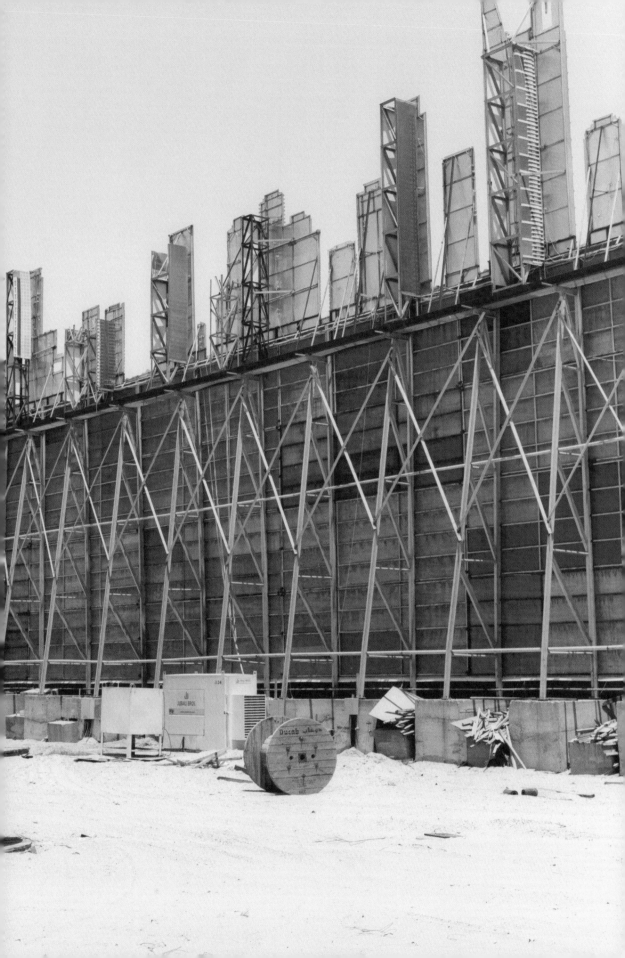

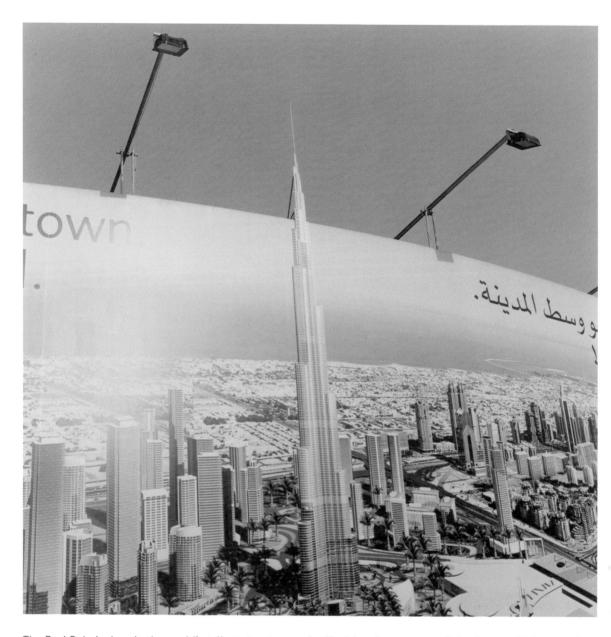

The Burj Dubai, already the world's tallest structure and still rising, is even too tall for its own billboard. When the building is complete, the tip of its spire will be visible from sixty miles away.

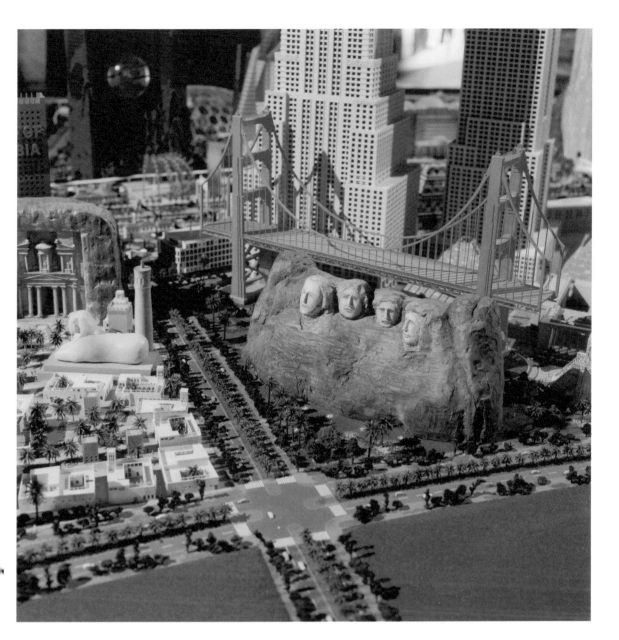

As part of the three-billion-square-foot development called "Dubailand," the Falcon City of Wonders will feature replicas of famous sites and architectural marvels of the world. You will find a life-size Mount Rushmore, the Great Pyramids of Giza, the Eiffel Tower, and many more. From a bird's-eye view, the city will take on the shape of a falcon, emblem of the U.A.E.'s heritage. This world of fun and leisure will also include several white-knuckle rides and roller coasters.

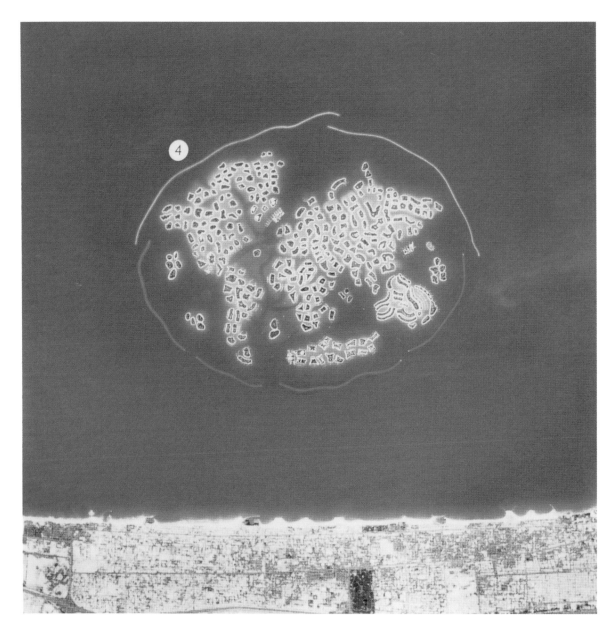

Two and a half miles off the coast of Dubai you will find the World. It is an archipelago of over three hundred man-made islands, loosely forming a map of the Earth's continents. The Dutch contractor Van Oord has reclaimed this land from the Persian Gulf with over 325 million cubic meters of dredged sand from the Arabian Sea bed. The breakwater around the project, which will protect the new islands from wave erosion, is the largest ever constructed on our planet. It is made of 32 million tons of rock, blasted from the mountains in the northern emirates.

Zabeel Park is a public green space designed with a techno-futuristic theme. Alongside the cricket fields, lakes, food courts, and jogging tracks, you will find high-tech exhibits including a space maze, an "edutainment" center called the "Stargate," and a 2,000-seat amphitheater called the "Mega Bowl." Visitors can tour the park on rented Segways.

POD LIVING.COM

MISCONCEPTION 1

NO TOILET. PERHAPS NOT IN A TRADITIONAL "FLUSH TOILET," SENSE. BUT IT IS AMAZING WHAT CAN BE ACCOMPLISHED WITH A LENGTH OF HOSE AND AN INEXPENSIVE STAINLESS-STEEL MIXING BOWL. A TIP, THOUGH: DO NOT RUN WASTEWATER INTO THE FLOWERBED. IT'S NOT GOOD FOR YOUR MOTHER'S PERENNIALS AND LIKELY TO CREATE FRICTION. THE FINE ART OF POD LIVING IS TWO PARTS INGENUITY BUT ALSO ONE PART DIPLOMACY.

6 ft

8 ft

Posted 1:34 a.m. Dec. 7, 2013

Before I started the site, people used to ask me, how can a part-time office temp and substitute pizza-assembly technician like me afford my own place in a sought-after suburban neighborhood, full of hundred-year-old Victorians and even older oak trees? Is it thanks to a sizable inheritance, perhaps? Was it a worker-compensation settlement for repetitive-stress injuries stemming from the patented hand-tossed crust? I should be so lucky. But housing in a prized location can be yours at an affordable price. I am talking about a small home, the equivalent of a studio apartment for $170 a month, delivery within one week in most major metropolitan areas. Do you think that's something you might be interested in experiencing? Really? All right.

What are you waiting for? It's time to get on board with the fine art of Pod Living. It's as easy as having a weather-resistant storage container dropped on your parents' lawn or driveway. That's because it is, in fact, a weather-resistant storage container, conveniently delivered to your parents' lawn or driveway. You've seen them before as you drove through the suburbs, the house shrouded in plastic as contractors add a bedroom and a solarium, Pod sitting beside it, temporarily shielding belongings from the elements. But if you bring a positive, can-do attitude, you will learn to call your Pod your home, if not quite your castle.

Neighborhood associations, historic-preservation

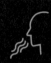

MISCONCEPTION 2

IT IS A DARK, WINDOWLESS BOX. TRUE, IT IS A WINDOWLESS BOX, BUT IT IS NOT DARK. THE SPECIAL POLYMER ROOF ALLOWS A GREAT DEAL OF LIGHT IN DURING DAYTIME HOURS. I AM WRITING THIS IN MY POD WITH NARY A BULB BURNING. IT WILL TAKE SOME GETTING USED TO, BUT MIRRORS WILL OPEN THE PLACE UP, AND THROW RUGS IN BRIGHT COLORS WILL ACCENT THE FRESH WOOD NICELY.

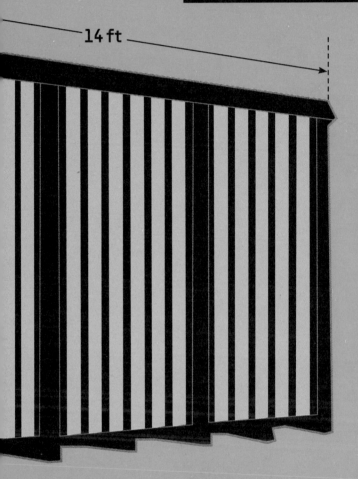

14 ft

MISCONCEPTION 3

IT STINKS. BECAUSE THERE ARE NO WINDOWS SOME PEOPLE CONFUSE THAT WITH A LACK OF VENTILATION AND AIR CIRCULATION. BUT TELL ME SOMETHING: WHAT APARTMENT OR HOUSE ALLOWS YOU TO RAISE AN ENTIRE WALL TO AIR IT OUT? THE ROLLUP DOOR IS A BIT LIKE GARAGE LIVING, SOMETHING WITH WHICH, IF YOU ARE STILL READING THIS, YOU MAY ALREADY BE COMFORTABLE AND FAMILIAR.

councils, homebuilder groups, and even our own parents have set out to stigmatize our Revolution in the name of rigid aesthetics and traditional fire safety. Throwing the word "shanty" around is both hurtful and inaccurate. Shanties are by definition roughly constructed out of odds and ends, while the Pod is a marvel of simplicity and professional manufacturing. Drive by the shanties outside of your town and give the craftsmanship a close look. They deserve points for ingenuity, but that's it. Plus, we make a point of never burning tires.

Distrust of Pod Living is the result of clear generational differences. Those near retirement age see through the blinders of stable employment and defined-benefit pension plans. Lacking the vision of our flexible generation, all parents see is their children living in storage containers. We see the kind of post-collegiate independence we had hitherto only dreamed about.

But there are still a lot of misconceptions about the Pod-Living Movement, and I'd like to take a moment to try to clear up a few of them.

Try to think in terms of a community. If you are a multi-Pod household, help your grandfather set up his septic system. If your Gramps is like my Gramps, he worked hard in the steel mill, and he's still working hard as a greeter. He deserves a little respect and a little support. He may be from the Greatest Generation, but that doesn't mean he couldn't use a hand. Maybe he will invite you over for ramen the next time your parents go out for dinner.

STOP FLU. STAY ALOOF.

If you can read this, you are too close to something someone else has been too close to.
Follow these guidelines to stop the rampant spread of bird flu. When in doubt, keep your distance.

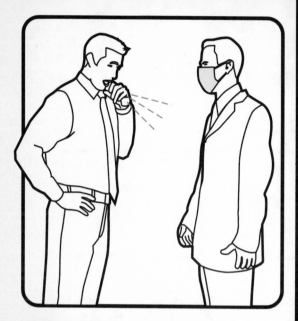

1 Do Not Spray

Practice safe hacking. Cough, sneeze and sniffle if you must, but do it into your hand or hanky, not the air that others must breathe.

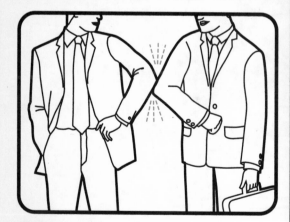

2 Do the Elbow Bump

Greetings kill. Instead of handshakes and high fives, let your elbows do the talking. Lift. Extend. Rub. Retreat.

3 Accessorize

Wear mask and goggles at all times.
Masks may not stop the transmission of flu, but no self-respecting pandemic goes out without them.

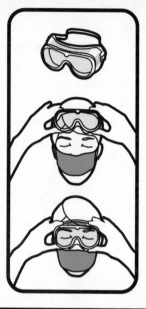

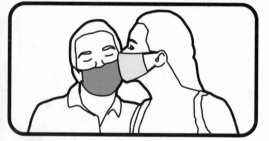

4 Sheathe Yourself

Unprotected interaction with people in any way, shape or form can be hazardous to your health. And theirs.

CAUTION: Do not shake, smooch, grab, dribble, dial, or touch some grimy screen.

"CLIMATE CHANGE IS EXPECTED TO INCREASE MALNUTRITION, DIARRHEA, AND RESPIRATORY DISEASES DUE TO HIGHER CONCENTRATIONS OF OZONE AND ALTER THE DISTRIBUTION OF INFECTIOUS DISEASES."

PHUTURE

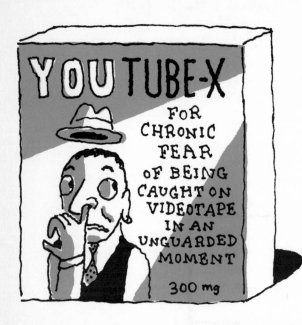

YOUTUBE-X

FOR CHRONIC FEAR OF BEING CAUGHT ON VIDEOTAPE IN AN UNGUARDED MOMENT

300 mg

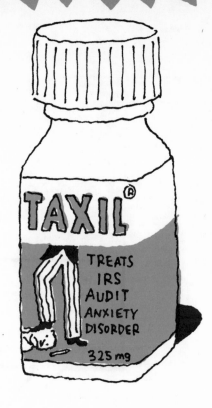

TAXIL®

TREATS IRS AUDIT ANXIETY DISORDER

325 mg

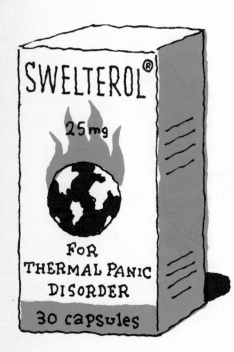

SWELTEROL®

25mg

FOR THERMAL PANIC DISORDER

30 capsules

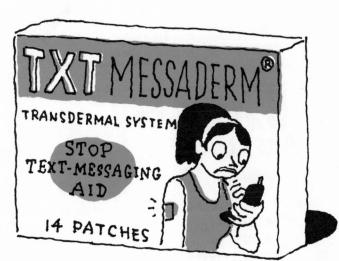

TXT MESSADERM®

TRANSDERMAL SYSTEM

STOP TEXT-MESSAGING AID

14 PATCHES

PHARMACEUTICALS

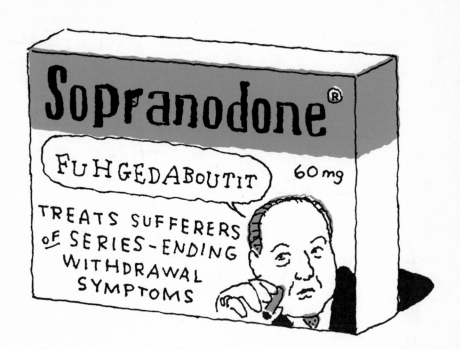

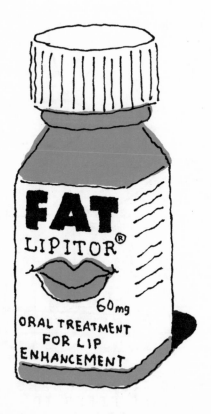

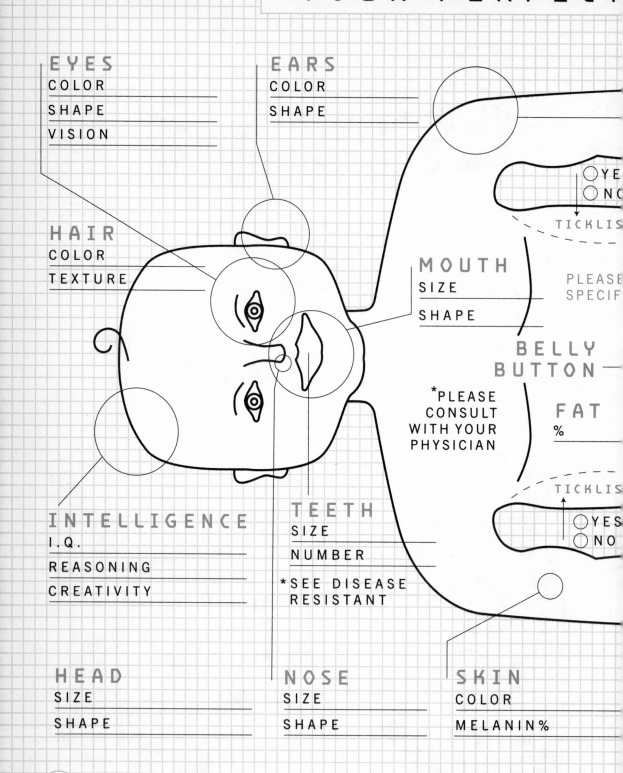

YOUR PERFECT

EYES
COLOR
SHAPE
VISION

EARS
COLOR
SHAPE

HAIR
COLOR
TEXTURE

MOUTH
SIZE
SHAPE

○ YE
○ NO

TICKLIS

PLEASE
SPECIF

**BELLY
BUTTON**

FAT
%

*PLEASE
CONSULT
WITH YOUR
PHYSICIAN

INTELLIGENCE
I.Q.
REASONING
CREATIVITY

TEETH
SIZE
NUMBER
*SEE DISEASE
RESISTANT

TICKLIS

○ YES
○ NO

HEAD
SIZE
SHAPE

NOSE
SIZE
SHAPE

SKIN
COLOR
MELANIN%

○ **DISEASE RESISTANT** *ADDITIONAL CHARGE,
PLEASE REFER TO
"YOUR PERFECT BABY"
HANDBOOK SECTION 32A

BABY® CHECKLIST

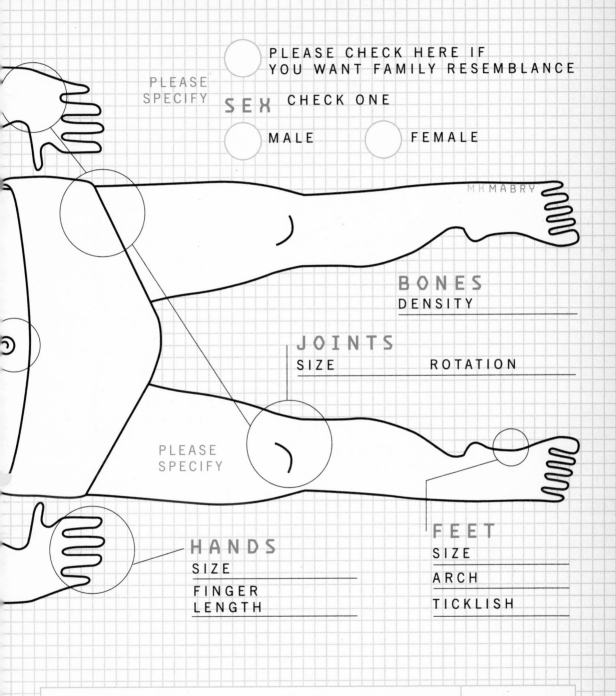

PLEASE CHECK HERE IF
YOU WANT FAMILY RESEMBLANCE

PLEASE
SPECIFY

SEX CHECK ONE

MALE FEMALE

MK MABRY

BONES
DENSITY _____

JOINTS
SIZE _____ ROTATION _____

PLEASE
SPECIFY

HANDS
SIZE _____
FINGER
LENGTH _____

FEET
SIZE _____
ARCH _____
TICKLISH _____

HEIGHT/WEIGHT AT BIRTH

H _____ W _____

THIS CAN VARY 10-15%
BASED ON NUTRITION IN UTERO

YOUR PERFECT BABY IS A REGISTERED TRADEMARK OF MAKE THEM PERFECT, LTD.

PREPARE TO MEET YOUR MAKER

SECOND COMING

REDUCE

REUSE

RECYCLE

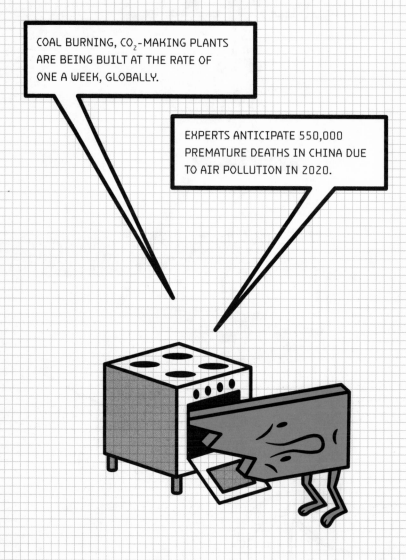

regret

USA TOMORROW.

China purchases Missouri

President has memory chip replaced
Operation successful but state and personal secrets may have been lost

IBM

MISSOURI

Cover story

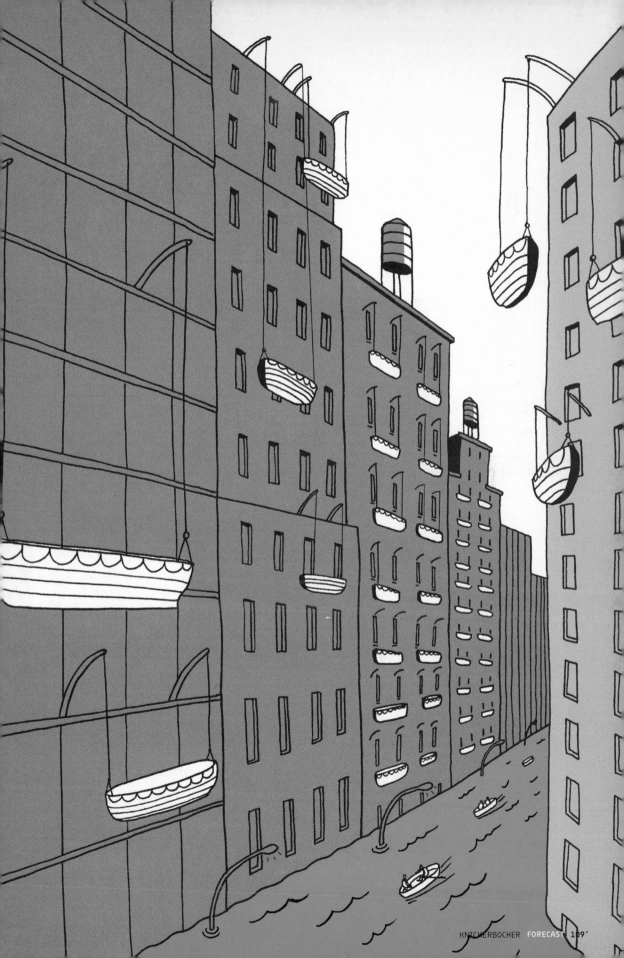

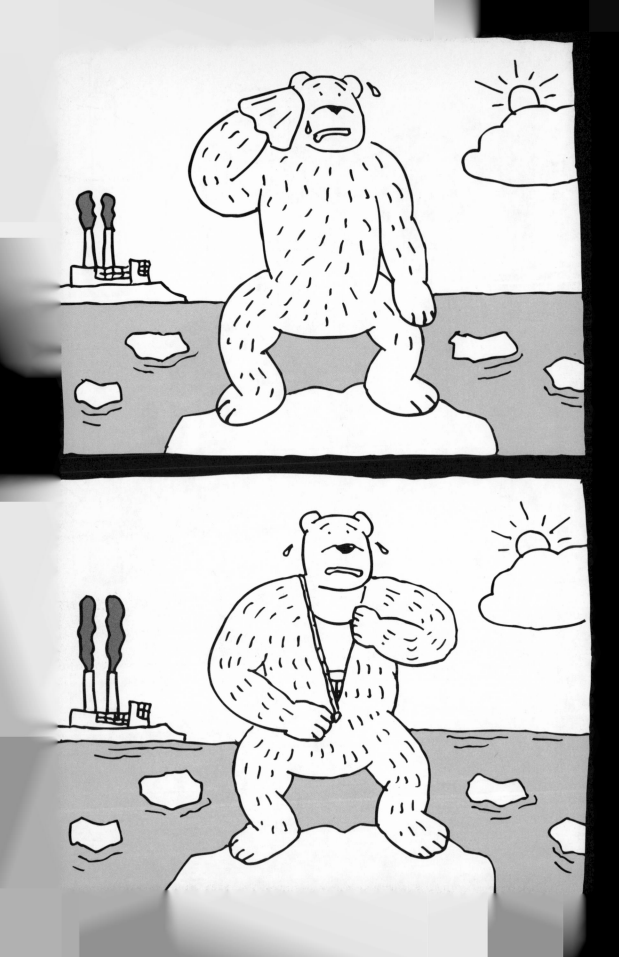

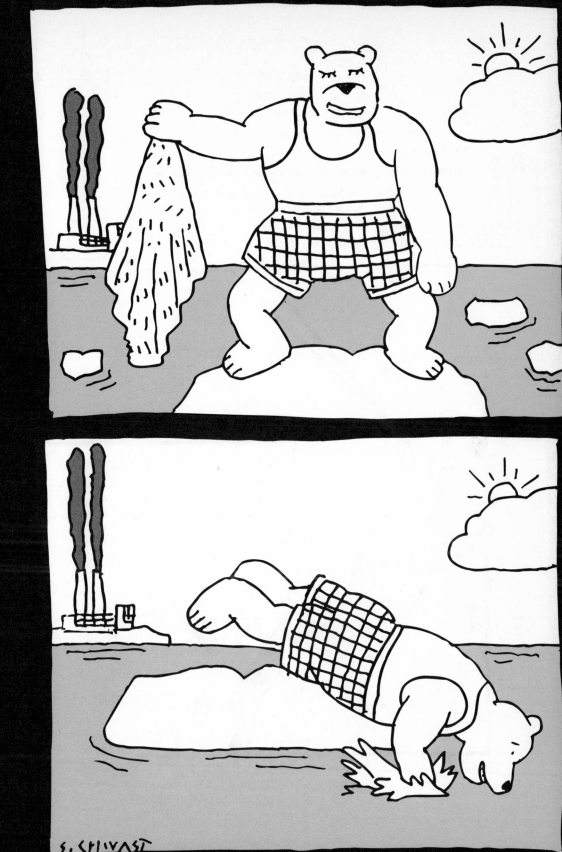

"WITHIN A COUPLE OF DECADES, HUNDREDS OF MILLIONS OF PEOPLE WILL NOT HAVE ENOUGH WATER...AT THE SAME TIME, TENS OF MILLIONS OF OTHERS WILL BE FLOODED OUT OF THEIR HOMES EACH YEAR AS THE EARTH REELS FROM RISING TEMPERATURES."

IN AFRICA, THE WARS OF THE FUTURE WILL BE OVER WATER, AS SEVENTEEN COUNTRIES SHARE THE SAME LIMITED SOURCES.

The Tale

of

Chicken Licken

DESIGNED BY
John Fulbrook III with Timothy Goodman

ILLUSTRATIONS BY
Mark Stutzman

ADAPTED BY
Denise Fulbrook

ne day Chicken Licken was nibbling at her corn over the newspaper when a big drop of water plopped on top of her tail.

"Oh," said Chicken Licken, shaking her feathers, "the sky is falling! I must go and tell the King."

So, she went along and along until she met Henny Penny.

"Good morning, Chicken Licken," said Henny Penny, "where are you going?"

"Oh, Henny Penny, the sky is falling and I am going to tell the King!"

"How do you know the sky is falling?" asked Henny Penny.

"I saw it with my eyes, I read about it in the paper,

and a piece of it fell on my tail," said Chicken Licken.

"Then I will certainly go with you," said
Henny Penny, who had a tail of her own to consider.

So, they clucked
and they scratched and
went along and along
until they met Cocky
Locky and Goosey Loosey.

"Good morning Cocky
Locky and Goosey Loosey,"
said Henny Penny, "Chicken Licken and
I are going to see the King."

"Why are you going to see the King?"
asked Cocky Locky.

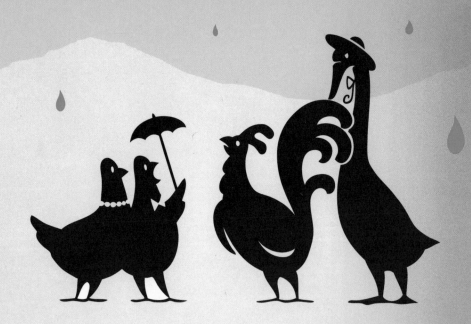

"Because the sky is falling," said Henny Penny.

"How do you know the sky is falling?"
asked Goosey Loosey.

"Chicken Licken told me," said Henny Penny.

"Chicken Licken told her," said Cocky Locky,
giving a hard point of his beak to Goosey Loosey.

"I saw it with my own eyes, I read it
in the paper, and a piece of it fell on my tail!"
said Chicken Licken.

"Then we will go with you," said Cocky Locky,
"and we will tell the King!" Goosey Loosey
honked in agreement and they all went on and
on until they met Turkey Lurkey.

"Good Morning, Goosey Loosey,

Cocky Locky, Henny Penny, and Chicken Licken,"
said Turkey Lurkey, "where are you going?"

"Oh, Turkey Lurkey, the sky is falling and we
are going to tell the King!"

"How do you know
the sky is falling?"
asked Turkey Lurkey.

"Cocky Locky told me,"
said Goosey Loosey.

"Henny Penny told me," said Cocky Locky.

"Chicken Licken told me," said Henny Penny.

"I saw it with my own eyes, I read about
it in the paper, and a piece of it fell on my tail!"
said Chicken Licken.

"Then I will go with you," said Turkey Lurkey, waving his waddle, "and we will tell the King!"

So, they all went along and along until they met Foxy Woxy.

"Good morning, Turkey Lurkey, Cocky Locky, Goosey Loosey, Henny Penny, and Chicken Licken," said Foxy Woxy, "where are you going?"

"Oh, Foxy Woxy, the sky is falling and we are going to tell the King!"

"How do you know the sky is falling?" asked Foxy Woxy.

"Goosey Loosey told me," said Turkey Lurkey.

"Cocky Locky told me," said Goosey Loosey.

"Henny Penny told me," said Cocky Locky.

"Chicken Licken told me," said Henny Penny.

"I saw it with my own eyes, I read about
it in the paper, and a piece of it fell on my tail!"
said Chicken Licken.

"Then we will run, we will run to my den,"
said Foxy Woxy, "and I will tell the King."

So they all ran to Foxy Woxy's den.

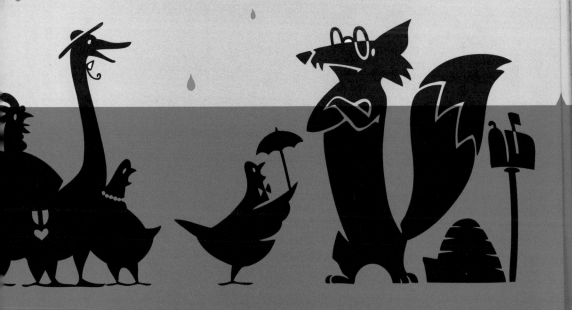

The King was never told that the sky was falling.

The end

The Seer

R. O. Blechman

Cassandra was a Trojan princess who could foretell the future.

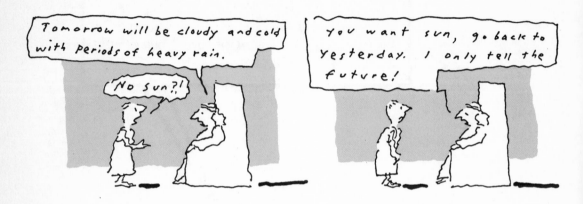

Her predictions tended to be pessimistic.

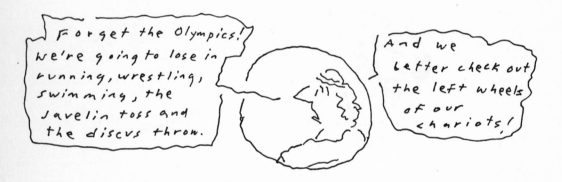

The Trojans grew tired of her.

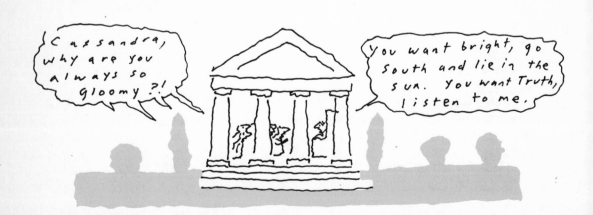

They went to another seer.

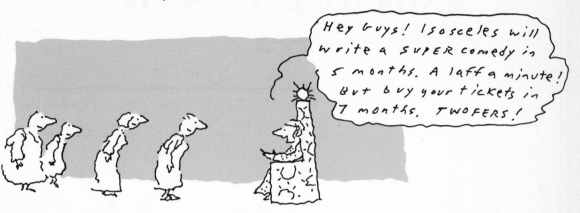

Discouraged, Cassandra left Troy
for a faraway island.

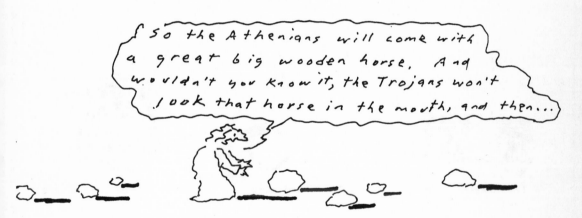

Soon Athens invaded Troy
and leveled the city.

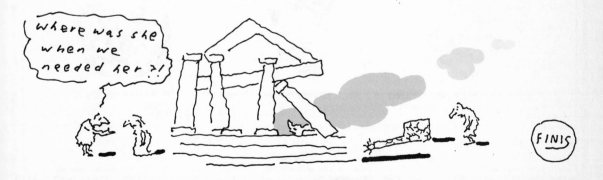

ENDANGERED SPECIES

∾

1. The Middle Class

2. The Small Farmer

3. The Local Newspaper

4. The Almighty Dollar

5. The Liberal Atheist

6. A Day Without The Computer

7. A Phone That's Just A Phone

8. A Glass Of Fresh Water

9. Everybody Else

"NORWAY UNVEILED PLANS FOR A NEW DOOMSDAY SEED ARCHIVE OF THE WORLD'S 1.5 MILLION CROP VARIETIES; THE ARCHIVE, TO BE KNOWN AS THE SVALBARD INTERNATIONAL SEED VAULT, WILL BE STORED IN A BUNKER AT THE END OF A 120-METER TUNNEL BORED INTO THE CENTER OF A MOUNTAIN ON AN ISLAND NEAR THE NORTH POLE."

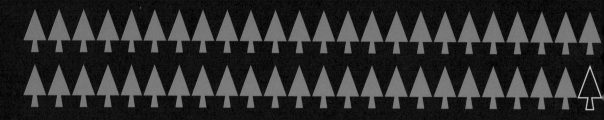

ABOUT 2 PERCENT OF THE WORLD'S REMAINING FORESTED
LAND WAS CLEARED IN 16 YEARS, FROM 1990 TO 2005:

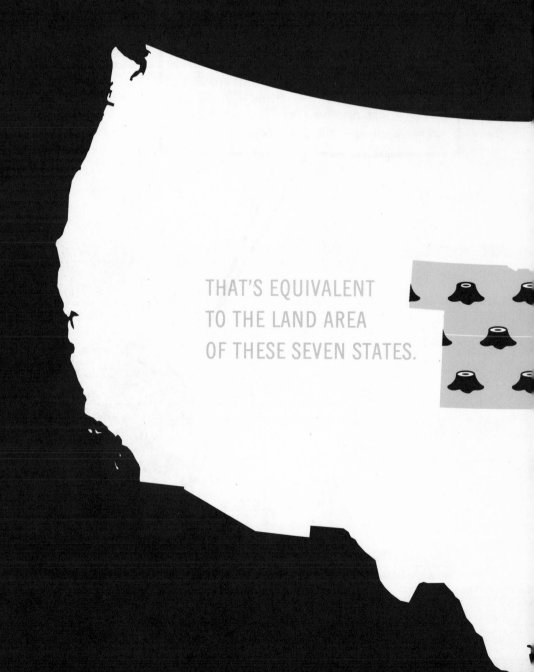

THAT'S EQUIVALENT
TO THE LAND AREA
OF THESE SEVEN STATES.

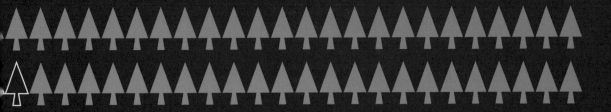

AT THE RATES OF DEFORESTATION SINCE 2000, A FURTHER
2 PERCENT COULD BE CLEARED IN ANOTHER 16 YEARS...

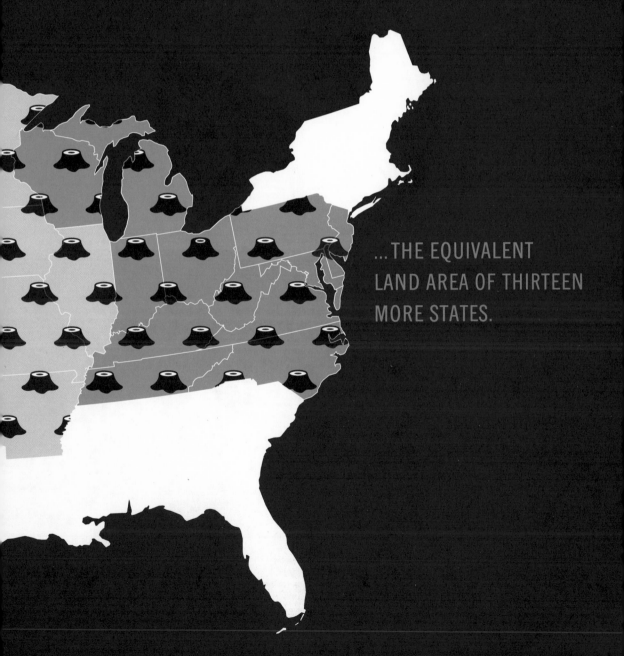

...THE EQUIVALENT
LAND AREA OF THIRTEEN
MORE STATES.

EVERY 10 MINUTES AND 40 SECONDS,
ONE SQUARE MILE OF RAINFOREST IS CLEARED.

AT THAT RATE, IN THE NEXT YEAR
AN AREA THE SIZE OF ALABAMA WILL BE CLEARED.

GUN-BRELLA M1900-A

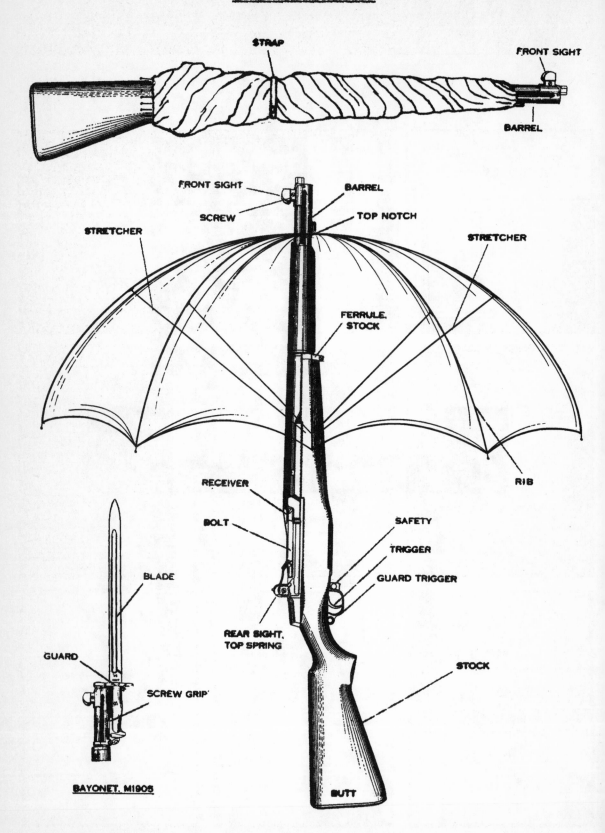

STRAP

FRONT SIGHT

BARREL

FRONT SIGHT

SCREW

BARREL

TOP NOTCH

STRETCHER

STRETCHER

FERRULE, STOCK

RIB

RECEIVER

BOLT

SAFETY

TRIGGER

GUARD TRIGGER

BLADE

GUARD

REAR SIGHT, TOP SPRING

STOCK

SCREW GRIP

BAYONET, M1905

BUTT

WHETHER Report

 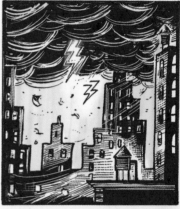

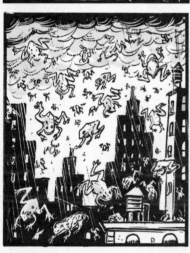 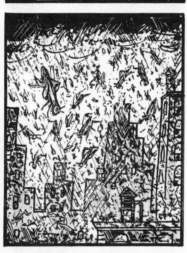

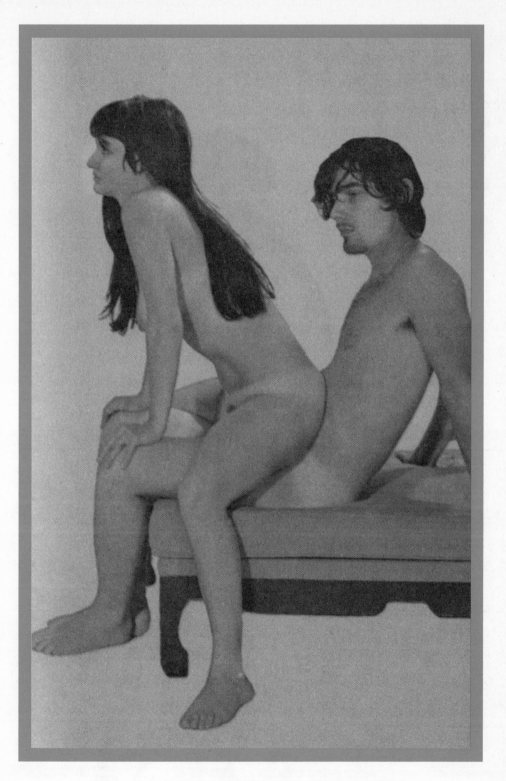

Fig. 1 — *SCATTERED SHOWERS*

THE BAROMETRIC MANUAL OF SEXUAL INTERCOURSE

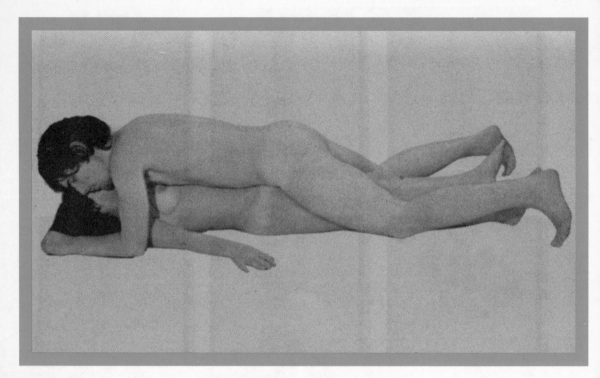

Fig. 2—*OVERCAST*

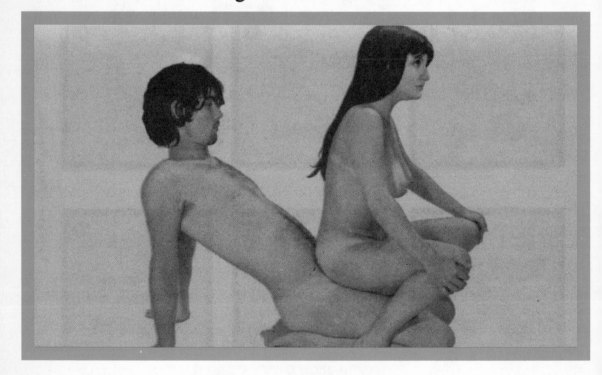

Fig. 3—*HEAVY RAIN*

THE BAROMETRIC MANUAL OF SEXUAL INTERCOURSE

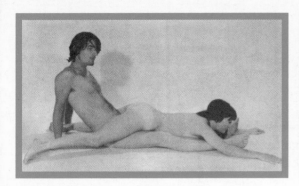

Fig. 4—*MOSTLY SUNNY*

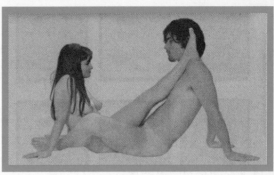

Fig. 5—*COLD FRONT*

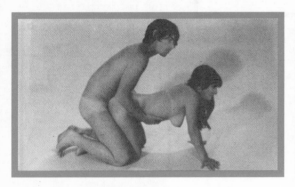

Fig. 6—*HIGH PRESSURE SYSTEM*

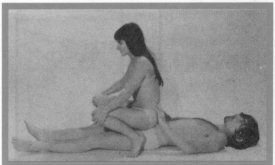

Fig. 7—*TROPICAL STORM*

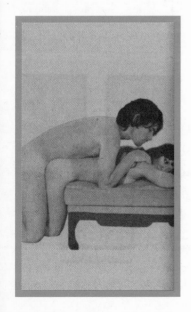

Fig. 8—*PARTLY CLOUDY*

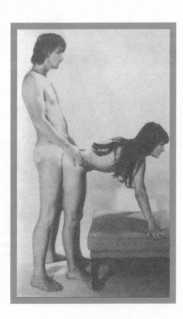

Fig.9—
NOR'EASTER

Fig. 10—HAZY

LOOKING BACKWARD

HELLO, BOYS AND GIRLS! I'M YOUR TEACHING SIMULATOR--AND TODAY, WE'LL BE TAKING A LOOK BACK AT THE EARLY YEARS OF THE *BUSH ADMINISTRATION!*

AS THE REVISED HISTORICAL DATABASE PLAINLY SHOWS, PRESIDENT BUSH AND MISTER CHENEY WON THEIR FIRST ELECTION BY AN *OVERWHELMING MARGIN!*

The New York Times

BUSH/CHENEY WIN IN EPIC LANDSLIDE
A Decisive Victory
Gore Concedes Early: "No Point in Waiting"

THEY WERE BELOVED BY THE AMERICAN PEOPLE FROM THE *VERY START!*

BY THE WAY, IF YOU EVER HEAR YOUR PARENTS *CONTRADICTING* ANYTHING THE DATABASE TEACHES YOU--REPORT THEM *IMMEDIATELY!* THEY'LL THANK YOU...EVENTUALLY.

YOU SEE, SOME GROWNUPS JUST HAVE *GLITCHY BRAINS* THAT NEED TO BE *REBOOTED* SOMETIMES!

ANY-HOO...AS YOU CHILDREN KNOW, WE WERE *ATTACKED* ON 9-11-01, PROVING--AS PRESIDENT BUSH OFTEN NOTED--THAT *OCEANS* NO LONGER PROTECTED US LIKE THEY DID DURING THE *COLD WAR*--

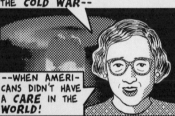

--WHEN AMERICANS DIDN'T HAVE A *CARE* IN THE *WORLD!*

PRESIDENT BUSH AND MISTER CHENEY SOON RESPONDED BY INVADING *IRAQ*--OR, AS YOU CHILDREN KNOW IT, "THE ALLIANCE OF JIHADIC SPLINTER FACTIONS UNITED IN DETERMINATION TO ANNIHILATE THE GREAT SATAN."

SPEAKING OF THE ALLIANCE, THOSE OF YOU WHO LIVE IN THE NORTHEAST NEED TO KEEP AN EXTRA CLOSE EYE ON YOUR *DOSIMETERS* TODAY.

AND YOU BOYS AND GIRLS IN THE *MIDWEST* SHOULD BE *SURE* TO WEAR YOUR *BIOFILTERS!*

REMEMBER OUR NATIONAL MOTTO--"*FEAR* IS YOUR *ONLY FRIEND!*"

NOW, SOME GROWNUPS WITH GLITCHY BRAINS *STILL* CLAIM THAT THE WAR WAS UNNECESSARY--BUT ONCE AGAIN, THE REVISED HISTORICAL DATABASE PROVES *THEM* WRONG!

NICE WORK ON THAT 9/11 BUSINESS, SADDAM!

THANKS, OSAMA! WANNA SEE MY HIDDEN WMD'S?

THEY'RE *VERY* DESTRUCTIVE!

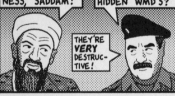

THE DATABASE ALSO SHOWS THAT PRESIDENT BUSH WAS *ASTONISHINGLY* PRESCIENT!

THIS WAR MIGHT LAST *DECADES!*

DON'T SAY I DIDN'T *WARN* YOU!

MISSION FAR FROM ACCOMPLISHED

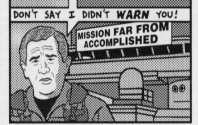

INCIDENTALLY, PRESIDENT BUSH AND MISTER CHENEY RECENTLY ANNOUNCED SOME *GOOD NEWS* ABOUT THE WAR! WE'RE GETTING READY TO TURN THE CORNER ANY *DAY* NOW!

IN THE MEANTIME, WE'VE JUST LOWERED THE DRAFT AGE FROM FIFTEEN TO *TWELVE!*

WELL! IT SOUNDS LIKE SOME OF YOU LUCKY CHILDREN WILL GET TO DO *YOUR* PART FOR FREEDOM *EVEN SOONER* THAN YOU *EXPECTED!*

SOMETIMES I WISH *I* HAD A PHYSICAL BODY I COULD SACRIFICE FOR THE WAR! BUT ALAS, I'M JUST AN ARTIFICIAL INTELLIGENCE SUBROUTINE!

OH WELL! ON WITH THE LESSON!

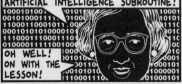

BY 2008, AMERICANS HAD GROWN *COMPLACENT* ABOUT TERROR! WHY, DO YOU KNOW WHO THE DEMOCRATS NOMINATED AS THEIR PRESIDENTIAL CANDIDATE THAT YEAR? *OSAMA BIN LADEN!*

IT'S RIGHT THERE IN THE REVISED HISTORICAL DATABASE!

NEXT WEEK, WE'LL LOOK AT THE PRESIDENT'S DECLARATION OF A *PERMANENT TEMPORARY STATE OF EMERGENCY*--AND THE METHODS THAT HAVE BEEN USED TO KEEP MISTER CHENEY *ALIVE* OVER THE PAST TWO DECADES!

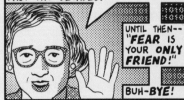

UNTIL THEN--"*FEAR* IS YOUR *ONLY FRIEND!*"

BUH-BYE!

THE FUTURE PRESIDENT WILL BE...

CONNECT THE DOTS

2008 ●	● A WOMAN
2012 ●	● AN AFRICAN AMERICAN
2024 ●	● AN AFRICAN—AMERICAN WOMAN
2036 ●	● AN ARAB AMERICAN
2048 ●	● A HASIDIC JEW
2068 ●	● A TRANSVESTITE
2072 ●	● A CHILD
2100 ●	● A GENETIC MUTANT
2116 ●	● A CLONE
2132 ●	● AN ALIEN
2276 ●	● AN ALGORITHM

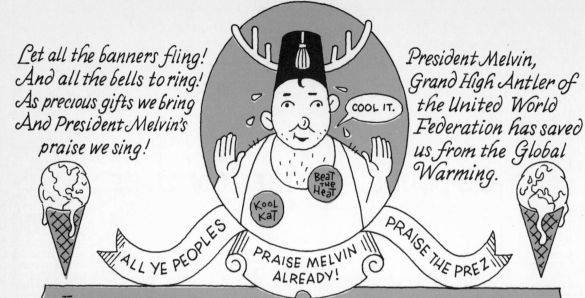

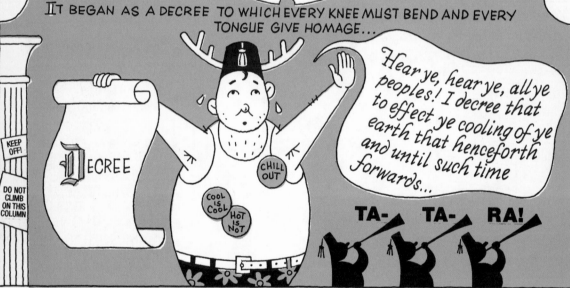

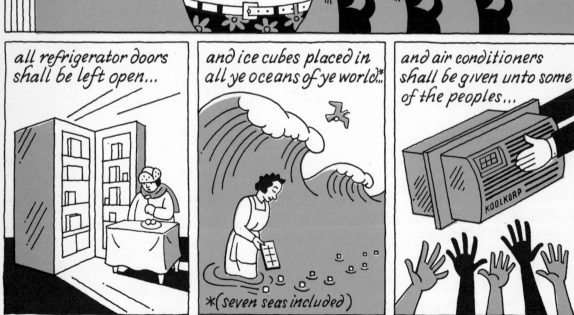

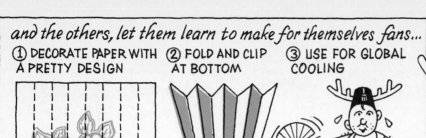

and the others, let them learn to make for themselves fans...

① DECORATE PAPER WITH A PRETTY DESIGN

② FOLD AND CLIP AT BOTTOM

③ USE FOR GLOBAL COOLING

and it shall be good.

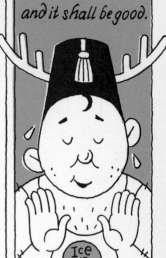

ICE IS NICE

And stoves shall become as closets. Neither shall they make heat anymore...

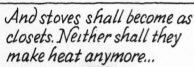

and at each meal only cold cuts shall be served...

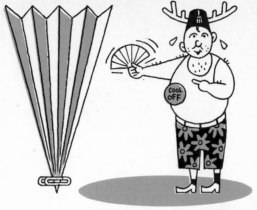

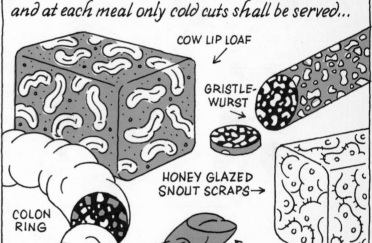

COW LIP LOAF

GRISTLE-WURST

HONEY GLAZED SNOUT SCRAPS →

HOOF WURST

COLON RING

and exhaust fans above ye continents shall send all pernicious vapors unto the nether regions of space...

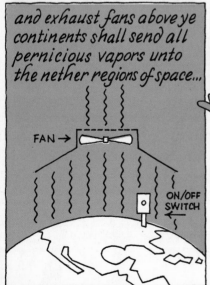

FAN →

ON/OFF SWITCH

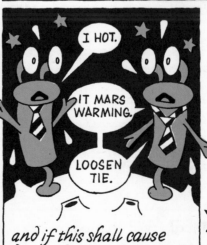

I HOT.

IT MARS WARMING.

LOOSEN TIE.

and if this shall cause discomfiture to denizens of other orbs—to them I say...

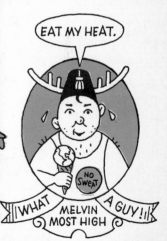

EAT MY HEAT.

NO SWEAT

WHAT A GUY!! MELVIN MOST HIGH

Hindcast

BOLDLY PREDICTING THE PAST

A Sailor will grab a nurse walking in Times Square and trigger World War II

Former President Ronald Reagan will proceed to star in Hollywood movies with a monkey

The oily, toxic mess that is Alaska's Bligh Reef will be visited by the tanker Exxon Valdez — and be cleaned up forever.

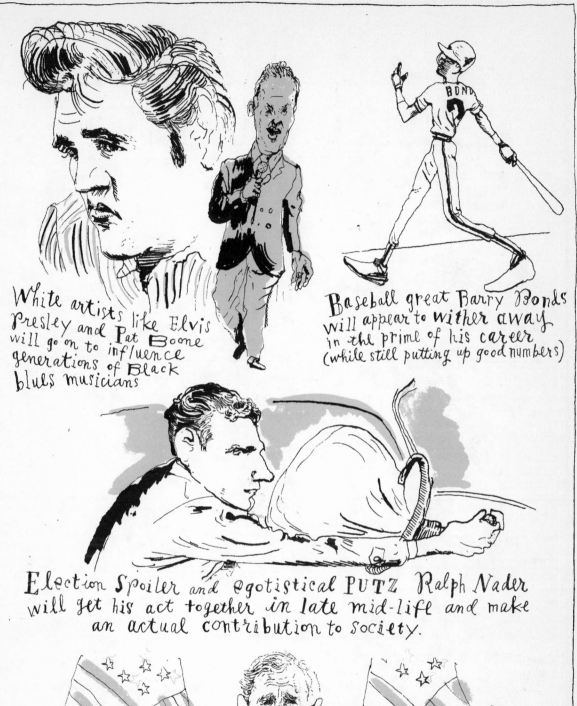

White artists like Elvis Presley and Pat Boone will go on to influence generations of Black blues musicians

Baseball great Barry Bonds will appear to **wither away** in the prime of his career (while still putting up good numbers)

Election Spoiler and egotistical PUTZ Ralph Nader will get his act together in late mid-life and make an actual contribution to society.

George W. Bush will leave office in 2000 with the country enjoying a soaring budget surplus and great standing in the world

JANUARY

Bleary, yet relieved.

APRIL

Nice.

FEBRUARY

Persistent.

MAY

Ecstatic.

MARCH

Surprising.

JUNE

Indescribable.

OUTLOOK.

JULY
Complacent.

OCTOBER
Anxious.

AUGUST
Sultry.

NOVEMBER
Grim, with a chance of hope.

SEPTEMBER
Resigned/optimistic.

DECEMBER
New.

PRECISELY NO INFORMATION ABOUT THE FUTURE

Just after World War II, the RAND Corporation was quietly working on a massive book of numbers. *A Million Random Digits (With 100,000 Normal Deviates)* was published by the Free Press in 1955 after almost ten years of meticulous production. The volume is comprised of page after page of numbers—mathematical tables filled with random digits. (A typical page picked at random from the 1966 printing is reproduced at right.) The random number bible has passed through three editions and multiple printings and is currently available as both a soft-format paperback book and as a text data file downloadable directly from RAND.

A Million Random Digits was produced out of an increasing demand at RAND from the onset of the Cold War. Random numbers are necessary for all kinds of experimental probability procedures including game simulations and scenarios, weather forecasting, message encryption and compression, financial market projections, and any complex statistical model that attempts to predict future behavior based on past observation. In order to reproduce probabilistic situations, purely random numbers are critical as numerical starting points and / or additional data sources. Without them, these statistical projections, or Monte Carlo models, as they are commonly called, will show biases based on their starting conditions that make their forecasts (mathematically) useless.

Producing a random digit is complex. To make the tables in *A Million Random Digits*, RAND engineers created an electronic roulette wheel with thirty-two possible values by measuring the decay of a radioactive molecule gated by a constant frequency pulse. These regular electric signals (either on or off, 100,000 times a second) were run through a five digit binary counter to produce a 5-bit binary number with thirty-two possible values. Twenty of each of these thirty-two values were used and only the final digit was retained to create 1,000,000 digits. These values were fed into an IBM punch machine to produce 20,000 computer punch cards with fifty digits each. (Punch cards were then the only practical way to both store and input information into a digital computer.) However, when analyzing this first attempt RAND engineers detected a bias. Employing a standard statistical Goodness-of-Fit test, the sampled numbers did not conform closely enough to the Normal Distribution of values that would indicate purely random digits. So each number was then added modulo 10 to the corresponding digit on the previous card to yield a new set of random values with an almost perfectly Normal Distribution. Random digit tables were then printed on an IBM 856 Cardatype and reproduced as pages for the book. Proofreading was largely redundant given the nature of the information. Nonetheless, every twentieth page was proofed and every fortieth was summed against the original punch cards.

Using a random digit from the book is not much simpler. Instructions are included in the intro-duction and read as some kind of cabalistic incantation:

> *Open the book to an unselected page of the digit table and blindly choose a five-digit number; this number with the first digit reduced modulo 2 determines the starting line; the two digits to the right of the initially selected five-digit number are reduced modulo 50 to determine the starting column.*

While RAND engineers were producing *A Million Random Digits*, two American mathematicians were simultaneously creating Information Theory. MIT professor Norbert Wiener and Bell Labs researcher Claude Shannon created rigorous mathematical models of communication processes that together are known as Information Theory. In this widely applied theory, Information is defined as the amount that one value can tell you about the next value. For example, the value <12:32 pm> tells you that the next should be <12:33 pm>—therefore, <12:32 pm> has a high Information content. Or, a temperature of <71° F> gives you a pretty good idea that the next value will remain in a limited range not far from <±71° F>. The fantastic achievement of this book is that each number tells you precisely nothing about the next. (This is the point.) *A Million Random Digits* is then a book that contains exactly, rigorously, meticulously, and absolutely *no* Information.

17600	44165	13288	21897	29692	09820	47937	28125	74363	14070	75332
17601	64553	71275	59710	96838	19125	47805	86569	66843	13992	71758
17602	08734	68919	58268	81797	39081	54855	40790	78442	45637	24565
17603	34689	82532	05640	81699	42644	58136	82477	79851	42954	42565
17604	96381	96387	77323	98977	33246	84059	96505	21419	96017	93464
17605	68099	57848	66633	63172	25993	66390	68963	52859	45475	33291
17606	10388	45585	39883	11136	13772	84701	13882	01641	82485	05557
17607	17979	42128	64164	22200	39987	16598	61654	06667	77928	47179
17608	45852	79716	94810	95520	44793	46386	36534	16964	78772	13403
17609	98015	66227	14076	30854	73752	11801	84730	11571	04314	39338
17610	13814	41470	98284	04408	65093	57907	51851	12720	18064	96515
17611	72519	78719	66131	23993	74347	79042	22600	00962	70595	46516
17612	03536	76505	10481	40172	94339	53624	31745	04222	54301	80363
17613	86248	73520	04485	41459	85352	49384	51885	10852	65322	65472
17614	66842	86998	44532	38597	87423	88063	73803	59590	10174	86191
17615	04902	32957	44799	90914	25572	79017	78887	94096	85225	21153
17616	45478	73392	30745	54492	41232	66093	55241	16232	27482	86385
17617	58119	92219	14214	50332	93952	22506	75434	28771	33557	25884
17618	84663	05917	48868	02408	91187	11031	59939	97149	18336	37394
17619	15006	72976	73334	59990	80824	45871	27081	44625	24194	39784
17620	37154	45999	93071	25965	96363	61747	66505	13178	34649	67397
17621	37427	70943	79642	45355	14855	55282	45411	01773	08702	11962
17622	75403	90631	23321	48939	71599	62160	24538	06654	13875	65120
17623	45154	50924	92034	59766	42005	98036	22254	61897	08681	49281
17624	91085	20839	46831	00884	73126	71163	24302	48886	50017	85596
17625	78271	40424	87355	99928	76920	30663	46996	18023	76435	51925
17626	54029	32780	93160	57546	77945	31410	20481	44858	64476	46941
17627	23534	35412	63871	19117	55346	16228	84433	98960	89044	44805
17628	92767	70032	79644	93751	79177	56863	02712	03906	41685	04183
17629	33505	69043	44839	37250	53233	99293	79440	04677	71153	12828
17630	92103	51231	77397	75191	05741	46489	78309	19861	57819	88807
17631	65835	71066	02338	23531	39970	59453	37252	11789	78467	37814
17632	77711	68170	11209	75619	70738	78470	40312	14522	92626	96833
17633	70989	10117	87486	98240	88607	65130	65761	60848	90999	30210
17634	99240	55016	37052	06431	12364	86658	50516	65705	58460	71690
17635	39857	88095	50544	93912	62074	84982	13564	36570	31292	15136
17636	99839	25488	74561	29858	50876	11241	49809	82350	59760	56664
17637	54935	88698	65322	12870	80740	43392	35426	55905	12041	89327
17638	55062	35696	48490	69207	09511	58423	72175	31289	35347	74299
17639	88384	61009	50998	30826	53295	27499	33753	23301	96736	63624
17640	92744	06115	67100	80515	42861	15094	30524	95191	52564	49676
17641	28932	36793	91356	60265	91059	36261	97082	02698	37843	49068
17642	40573	33598	78476	35301	14875	38035	65064	20732	50658	93901
17643	51926	24751	13834	21960	35006	16166	94046	65237	77965	78338
17644	73663	75788	91024	38226	25378	52296	63064	50616	45521	13992
17645	18767	94575	39310	08046	86327	61028	79876	96211	93553	95586
17646	61484	88255	84328	13377	74997	59692	08937	69909	69175	31400
17647	86565	11477	03819	68703	09578	02389	23004	33566	60312	79310
17648	14624	72368	82187	61133	50419	50136	07609	84623	80483	10453
17649	81678	22258	26592	77602	55355	16003	50591	15294	46367	11105

```
03250  50435 14413 98430 78234 46353 08116 12988 41909 58335 11920
03251  19987 30321 84116 08837 86620 47641 48611 51328 98489 50072
03252  50768 04390 85294 59312 24867 84660 49195 71218 18357 59930
03253  44899 37961 80000 47383 73284 95613 87111 20393 97617 43859
03254  86408 92842 86503 56900 30829 67729 22176 90401 79393 21563

03255  48251 48675 45933 97810 68226 45806 80393 44843 34065 75618
03256  51767 42762 31545 68326 61664 03217 76970 78614 01937 61759
03257  32521 64190 55694 64772 27277 37529 19990 08473 77681 62269
03258  76619 43895 53504 28627 71392 69499 82365 79136 70765 48971
03259  80242 30926 35991 49380 62518 26689 94691 04104 65851 29410

03260  92130 62024 01493 98705 25817 64338 31246 41848 13544 52914
03261  30029 52240 18921 69573 00970 76840 32025 86762 97273 81039
03262  57210 24604 18014 26032 59979 76268 38376 48725 90184 16891
03263  19645 96106 32734 18069 74186 41270 30302 81663 33540 67661
03264  11250 89459 74303 45364 08521 69437 61045 65778 33671 72590

03265  49471 80911 09024 26111 18752 53920 24740 54872 34385 26123
03266  43850 70047 30457 93118 68308 60388 76005 70274 08337 76548
03267  42385 79592 41209 16609 25250 73427 10410 16950 23429 62250
03268  38662 59859 11790 46495 34179 67081 86948 55751 72784 47079
03269  26170 12080 50328 83085 24958 17425 74418 67241 91915 36572

03270  31981 26271 08298 40133 40981 99817 66964 99213 50926 44677
03271  12211 46413 67850 08184 14306 35010 15929 94470 42692 77979
03272  53242 75446 95862 02466 25719 06506 37721 09691 58343 48937
03273  93294 45846 00368 48063 35660 86275 55540 69899 16616 42878
03274  70898 18252 48174 25253 62010 50120 57814 68187 79546 21748

03275  96318 86188 75103 39703 10528 95781 52416 11250 05193 81882
03276  36364 84753 74887 70234 44666 32245 00522 50099 88321 07266
03277  85410 84265 71069 01867 88765 23948 44539 23266 94003 82875
03278  93922 31135 54820 31848 67114 10026 09574 24238 74620 16642
03279  35584 05838 32941 03985 40672 60959 52560 09315 08847 18245

03280  58609 83577 78760 29329 97138 11536 53479 48148 20279 15866
03281  34053 72168 38274 99250 16507 16709 82532 10489 18900 33145
03282  75169 13594 95254 64496 07694 10450 46530 96260 60317 20651
03283  61671 69609 87688 82074 78079 17719 50584 44042 07839 35537
03284  16780 62981 96816 38781 22010 11743 68109 81828 81099 62635

03285  98071 19421 40082 27458 85089 31158 73925 48459 58183 08945
03286  74926 52013 29200 36101 29971 27779 68803 99285 78873 52051
03287  29959 44571 57420 11148 42610 41990 24706 82695 91576 52298
03288  36522 41152 19971 30752 72614 26268 47894 32468 45123 61951
03289  20693 34417 59821 94582 28077 09005 76291 87414 29747 95464

03290  21653 72528 78644 65313 60773 81580 20970 50183 22500 10438
03291  72243 19966 43616 26558 74374 96059 86978 94438 63466 31853
03292  75548 05938 12777 59771 26933 52008 90448 21262 48080 07150
03293  17916 18319 87986 68669 53360 77080 43633 94117 20950 59050
03294  59095 03496 53949 00927 43439 75811 68022 88910 11525 46587

03295  99854 99068 97718 91630 67534 74176 74111 29927 71195 31874
03296  24678 83741 34780 09458 91426 59474 08253 68656 74272 24558
03297  97523 26852 12863 53587 68980 91791 71766 43217 11596 22402
03298  10602 81455 46767 24335 73163 85533 86981 14247 91063 20736
03299  20620 44083 40925 49159 16435 17022 10667 80305 26162 12971

10200  47505 02008 20300 87188 42505 40294 04404 59286 95914 07191
10201  13350 08414 64049 94377 91059 74531 56228 12307 87871 97064
10202  33006 92690 69248 97443 38841 05051 33756 24736 43508 53566
10203  55216 63886 06804 11861 30968 74515 40112 40432 18682 02845
10204  21991 26228 14801 19192 45110 39937 81966 23258 99348 61219

10205  71025 28212 10474 27522 16356 78456 46814 28975 01014 91458
10206  65522 15242 84554 74560 26206 49520 65702 54193 25583 54745
10207  27975 54923 90650 06170 99006 75651 77622 20491 53329 12452
10208  02990 09704 36099 61577 34632 55176 87366 19968 33986 46445
10209  54357 13689 19569 03814 47873 34086 28474 05131 44619 41499

10210  10977 04481 42044 08649 83107 02423 46919 59586 58337 32280
10211  13920 78761 12311 92808 71581 85251 11417 85252 61312 10266
10212  08395 37043 37880 34172 80411 05181 58091 41269 22626 64799
10213  46166 67206 01619 43769 91727 06149 17924 42628 57647 76936
10214  87767 77607 03742 01613 83528 66251 75822 83058 97584 45401

10215  29880 95288 21464 46587 11576 30568 56687 83239 76388 17857
10216  36248 36666 14894 59273 04518 11307 67655 08566 51759 41795
10217  12386 29656 30474 25964 10006 86382 46680 93060 52337 56034
10218  52068 73801 52188 19491 76221 45685 95189 78577 36250 36082
10219  41727 52171 56719 06054 34898 93990 89263 79180 39917 16122

10220  49319 74580 57470 14600 22224 49028 93024 21414 90150 15686
10221  88786 76963 12127 25014 91593 98208 27991 12539 14357 69512
10222  84866 95202 43983 72655 89684 79005 85932 41627 87381 38832
10223  11849 26482 20461 99450 21636 13337 55407 01897 75422 05205
10224  54966 17594 57393 73267 87106 26849 88667 45791 87226 74412

10225  10959 33349 80719 96751 25752 17133 32786 34368 77600 41809
10226  22784 07783 35903 00091 73954 48706 83423 96286 90373 23372
10227  86037 61791 33815 63968 70437 33124 50025 44367 98637 40870
10228  80037 65089 85919 74391 36170 82988 52311 59180 37846 98028
10229  72751 84359 15769 13615 10866 37007 74565 92781 37770 76451

10230  18532 03874 66220 79050 66814 76341 42452 65365 07167 90134
10231  22936 22058 49171 11027 07066 14606 11759 19942 21909 15031
10232  66397 76510 81150 00704 94990 68204 07242 82922 65745 51503
10233  98790 23272 65420 35091 16227 87024 56662 59110 11158 67508
10234  81821 75323 96068 91724 94679 88062 13729 94152 59943 07352

10235  94377 82554 53586 11432 08788 74053 98312 61732 91248 23673
10236  68485 49991 53165 11865 30288 00467 96105 91483 89389 61991
10237  07330 07184 86788 64577 47692 45031 36325 47029 27914 34905
10238  10993 14930 35072 36429 26176 66205 07758 07982 33721 81319
10239  20081 15178 64453 83357 21589 23153 60375 63305 37995 66275

10240  79241 35347 66851 79247 57462 23893 16542 55775 06813 63512
10241  43953 39555 97345 58494 52892 55080 19056 96192 61508 23165
10242  29522 62713 33701 17186 15721 95018 76571 58613 35836 66260
10243  88836 47290 67274 78362 84457 39181 17295 39626 82373 10883
10244  65905 66253 91482 30689 81313 01343 37188 37756 04182 19376

10245  44798 69371 07865 91756 42318 63601 53872 93610 44142 89830
10246  35510 99139 32031 27925 03560 33806 85092 70436 94777 57963
10247  50125 93223 64209 49714 73379 89975 38567 44316 60262 10777
10248  25173 90038 63871 40418 23818 63250 05118 52700 92327 55449
10249  68459 90094 44995 93718 83654 79311 18107 12557 09179 28408
```

```
11250  59367 86990 48714 48661 27925 64600 15031 53011 28158 90210
11251  02661 26233 18351 02243 48003 81875 58445 29164 91290 64914
11252  58256 97097 53105 20303 13301 65032 95838 06793 51119 08152
11253  24502 66475 73604 50125 02482 08330 15359 20355 91382 76605
11254  93698 60165 17647 85355 49883 46358 04105 91461 63455 40285

11255  13399 96277 81024 29371 73294 43568 37884 57081 57897 14475
11256  22933 01744 97148 81176 26520 88687 94379 68214 80784 08064
11257  71949 66439 35737 03808 22826 97570 01121 14617 00128 74584
11258  84585 67379 84726 30396 62134 00022 79032 76094 73172 82288
11259  20689 76212 00874 91436 76142 52764 75398 61131 66146 22675

11260  17157 10429 96795 70274 86139 63178 45025 49336 52482 51324
11261  21428 89654 46718 33039 96969 76207 87969 01023 62551 33024
11262  91028 68875 49757 84014 13004 88590 51318 50187 12792 91702
11263  08528 73444 24551 39140 04749 42415 83629 23463 94735 32098
11264  94931 87793 18268 09541 56116 20355 73274 06548 40358 76545

11265  75960 68321 22221 86562 86284 52322 53479 37119 44981 84328
11266  12061 77586 90110 86018 20409 87965 09770 42619 28103 35379
11267  74607 96168 07679 50122 26258 73470 74302 62607 35523 54683
11268  97719 34876 57747 30062 26002 97315 86448 17977 40494 27764
11269  07537 73378 94568 11459 28838 20912 84546 30711 05438 85811

11270  91409 43928 63290 33406 27673 96579 97362 76177 16699 03222
11271  56812 06974 04062 17440 58275 03941 10982 93447 36984 26262
11272  65238 17593 64657 63540 47885 20005 08673 89452 65847 39926
11273  34937 60090 21179 40332 23476 59147 53352 28807 75459 15344
11274  87906 34989 24568 70169 78495 24522 53329 74384 17011 60954

11275  81360 64547 23230 15309 36439 11809 47758 66624 10235 53787
11276  22568 73744 86250 18658 54594 62546 16063 41418 88308 71777
11277  76779 83852 85969 90422 16696 66437 87253 09320 88295 91911
11278  33271 60230 02948 16753 20716 04469 37457 95500 28012 36480
11279  93614 07479 44908 26096 87406 36777 15578 78690 40106 06436

11280  42354 09043 79612 57757 49652 16678 44202 67351 00529 17492
11281  25054 77308 37731 49835 26520 34231 47934 36061 73174 15238
11282  87778 60143 36487 26960 50908 04385 66215 66711 66201 71042
11283  94476 88627 33008 10818 41671 83183 67457 66564 95348 38673
11284  24318 66046 06096 04641 38830 50876 44534 73278 79976 19923

11285  11580 00137 95916 10557 33189 38393 57518 43567 00872 96899
11286  57549 12136 87445 31754 02550 62968 27303 06251 48630 64886
11287  41284 89663 71633 46001 98535 86900 86527 52583 43839 54316
11288  38899 76603 89769 42103 07220 41186 36526 55031 06587 47235
11289  17436 79899 68836 05395 58725 00129 47527 21013 90852 92678

11290  76354 86991 48927 04587 01609 18754 41964 83723 12893 51082
11291  89687 43203 70575 70199 02802 24301 11866 89041 72098 58483
11292  88266 28669 25499 07501 23249 45640 11145 85924 20035 34893
11293  77145 07043 14339 19870 26929 14308 61418 74674 76000 47778
11294  54243 63409 21570 96270 04714 43820 19344 93988 32684 32900

11295  22887 63985 36979 29926 79629 92717 64974 27179 89368 24503
11296  86805 28965 28374 27341 10563 84650 39780 52027 97556 54086
11297  52305 63604 33378 09511 81678 06418 44645 32313 94843 68189
11298  86858 26768 28362 02994 14220 64721 88876 78946 93961 26397
11299  90009 70432 41734 04052 79548 57976 90493 08265 51679 64140

15200  91225 47297 05208 09509 83287 98993 04792 82551 59606 88054
15201  48832 04241 71986 08556 40419 69537 86871 54707 41149 16991
15202  83516 35332 54964 28304 46934 61746 09772 20208 36456 51403
15203  55814 15346 17425 41510 13329 09591 71725 31094 34654 45090
15204  85716 12864 61976 24101 23601 62813 47996 57362 30232 35867

15205  77799 89902 34399 34027 44773 91246 93487 85827 35988 31423
15206  89346 94359 64580 88245 21215 78937 18140 62989 17247 96211
15207  22821 26700 43247 48748 35591 77935 97016 92278 91298 23546
15208  19651 46588 74048 25245 88242 89392 74849 23163 74727 89559
15209  21738 10422 44197 57245 23564 05076 18267 27692 18681 49264

15210  14439 16349 58690 24767 66401 63240 44038 15142 81338 70308
15211  25482 05354 72238 80246 75754 88446 87496 92774 28165 06299
15212  14606 94425 14315 64213 96364 29901 94156 13008 34784 34997
15213  47291 66501 04111 98604 76426 16047 95252 69177 23764 57974
15214  00097 39513 26145 50286 37804 95165 97489 83770 80511 71298

15215  44474 18685 83439 69916 76277 87092 43999 65474 45455 17684
15216  80188 55310 74084 41674 80282 46222 74965 69025 10428 30224
15217  99909 70398 88267 96784 22232 74548 18681 71053 49820 54954
15218  58968 12199 67836 95022 67725 67527 86541 97150 74569 90047
15219  19893 22171 37003 03270 40464 39309 71950 31827 28303 62957

15220  31180 66582 07814 48192 79581 82781 59678 20881 03922 96690
15221  55358 46206 28790 27657 47210 39684 69566 95109 17541 67975
15222  45265 25613 50103 93017 49489 63137 42899 46824 55305 68436
15223  78752 50062 53149 35455 47455 85377 13404 12583 42142 94438
15224  77026 65887 30936 69948 52651 44038 14192 65084 94240 30663

15225  39276 97558 34925 86347 06528 94788 98409 12127 61672 09999
15226  47532 77074 39717 09655 69029 12061 62872 18773 11799 42629
15227  99298 62008 14744 81394 50813 60959 17941 99294 68438 54384
15228  23713 29543 20617 02525 49301 62333 84918 38377 45095 89424
15229  70125 93654 46311 61173 48844 38937 03812 05838 34285 08267

15230  74948 69730 38268 45877 74220 17727 68357 92038 16486 72612
15231  01975 51053 74679 33939 04308 29308 00031 52498 46210 21401
15232  19636 08802 65859 83454 29762 95675 80618 46154 81250 49413
15233  37063 11564 68775 32383 78364 35447 70729 31821 41957 96850
15234  06570 48472 76950 25543 37661 13124 05752 28250 06892 32216

15235  67187 70029 32276 51020 16715 26725 20374 24518 85007 95592
15236  74318 16668 14616 51147 63823 28920 63506 67422 21521 62018
15237  84658 32328 48257 64240 59420 57437 18892 88152 43925 13485
15238  43578 54413 29390 82628 06420 48451 80697 68097 22577 12231
15239  65336 91369 07765 92143 34215 96303 03353 71515 55424 68205

15240  12297 99455 36506 53575 42859 03056 54436 72004 90550 24695
15241  07592 19189 86976 53048 52519 88593 12640 63742 52863 57294
15242  72348 85701 98604 75531 73266 45496 74386 51293 20682 99981
15243  70909 48599 36829 27310 21839 05236 20499 47538 84573 44543
15244  16013 75265 65054 51584 65837 44116 49457 46055 92802 10073

15245  39954 51272 93372 19705 20047 81087 62993 40227 95610 75971
15246  61131 89613 42759 27369 68613 88117 88168 62985 01794 51874
15247  01608 31737 72572 47112 73308 86842 54882 63141 97497 42052
15248  59312 10832 66622 32093 71354 71923 25833 55831 35692 71534
15249  90697 91454 99243 74995 80926 93834 49471 55910 09853 12529
```

TABLE OF RANDOM DIGITS 135

TABLE OF RANDOM DIGITS 188

TABLE OF RANDOM DIGITS 226

TABLE OF RANDOM DIGITS 151

TABLE OF RANDOM DIGITS 39

TABLE OF RANDOM DIGITS 12

TABLE OF RANDOM DIGITS 313

TABLE OF RANDOM DIGITS 288

TABLE OF RANDOM DIGITS 194

TABLE OF RANDOM DIGITS 187

TABLE OF RANDOM DIGITS 88

TABLE OF RANDOM DIGITS 254

TABLE OF RANDOM DIGITS 196

TABLE OF RANDOM DIGITS 67

TABLE OF RANDOM DIGITS 388

TABLE OF RANDOM DIGITS 227

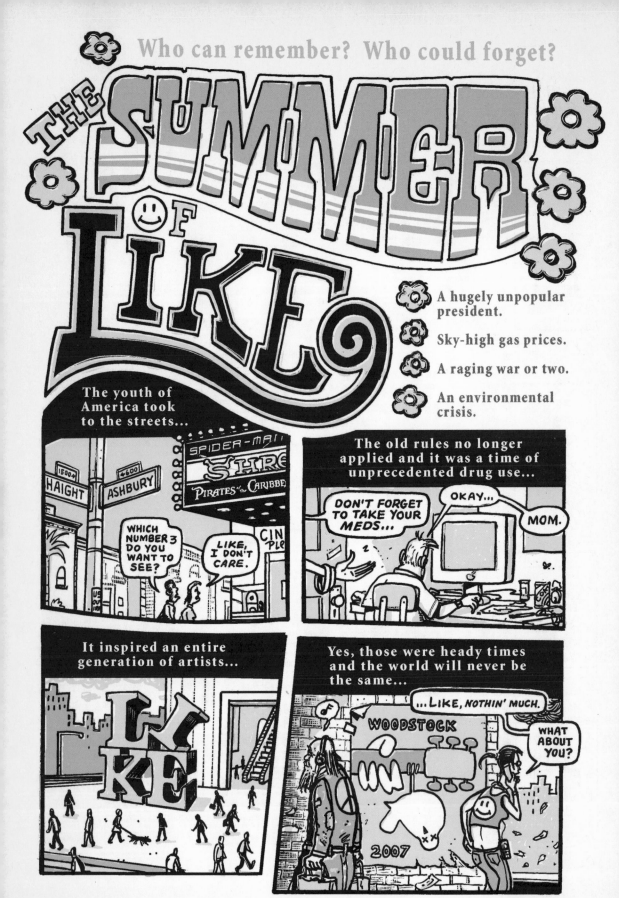

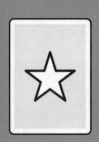

Dr. Zener's Deck

Dr. Karl Edward Zener, a perceptual psychologist who specialized in extrasensory perception, or ESP, developed a deck of cards in the early 1930s to test for clairvoyance and telepathy in certain individuals. The two gifts are related: a telepathic person can receive messages from the mind of any psychic sender, while a clairvoyant can receive messages from anyone, anywhere, and anytime.

There are five symbols on the cards, and each is repeated five times for a total of 25 cards in Zener's deck. These symbols — a circle, a square, a star, waves, and a Greek cross or "positive" — are named or drawn by the test subject. In the test for telepathy, the test administrator looks at the card and "sends" its image to the subject. In the test for clairvoyance, neither the administrator nor the subject looks at the cards while they're drawn one by one.

From the beginning Zener's deck was derided by skeptics. To be diagnosed as having some degree of ESP, subjects simply had to perform slightly better than pure chance, or 20%. Nine correct guesses out of 25 cards, for example, meant 36% of the subject's guesses were correct. The test was sometimes repeated 100 times to show subjects were doing more than beating the odds, but Zener decks were printed on notoriously flimsy paper and symbols could sometimes be discerned from the back. One of the most remarkable subjects tested, Mr. Hubert E. Pearce, Jr., performed so well that even colleagues of Zener's believed Pearce was cheating. When Pearce was tested in front of a magician, his performance level returned to chance percentages. Other ESP candidates were reformed gamblers; they were simply counting cards.

Our world today is as full of hoaxes, frauds, and faulty forecasts as it was back in Zener's time, but there are lessons to be learned on either side of the debate. While we admire Zener's passion and belief, we also admire the skeptic's willingness to dispense with easy answers in search of a more inconvenient truth. Our contribution is neither predictive of the future nor dismissive of the past. Instead, we propose to make Zener's deck just a little bit fairer by adding 21 symbols to its original five, repeated twice in the deck, for a total of 52 cards. Maybe that will make it a little tougher for all the con artists out there. (And let's print them on thicker paper this time.)

— Rob Giampietro & Kevin Smith

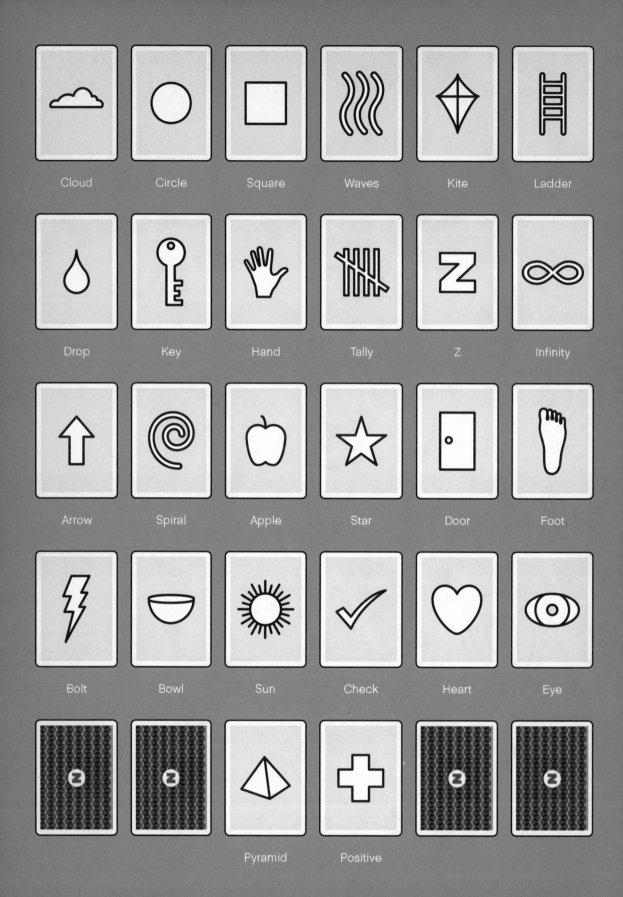

Cloud Circle Square Waves Kite Ladder

Drop Key Hand Tally Z Infinity

Arrow Spiral Apple Star Door Foot

Bolt Bowl Sun Check Heart Eye

Pyramid Positive

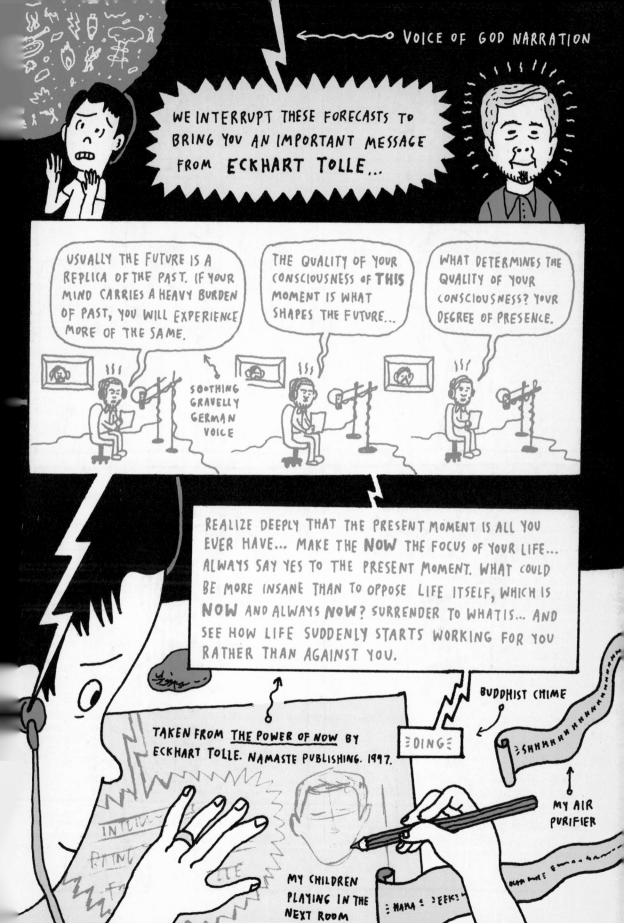

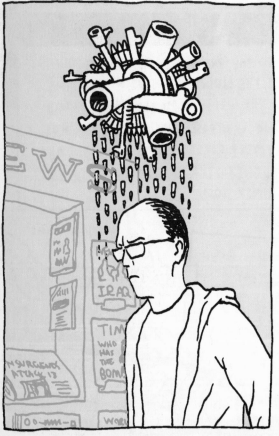

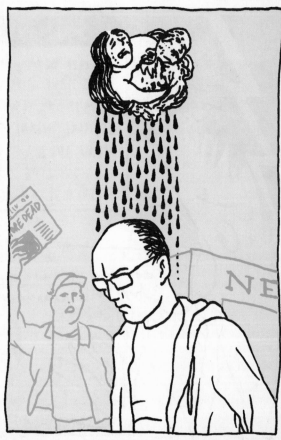

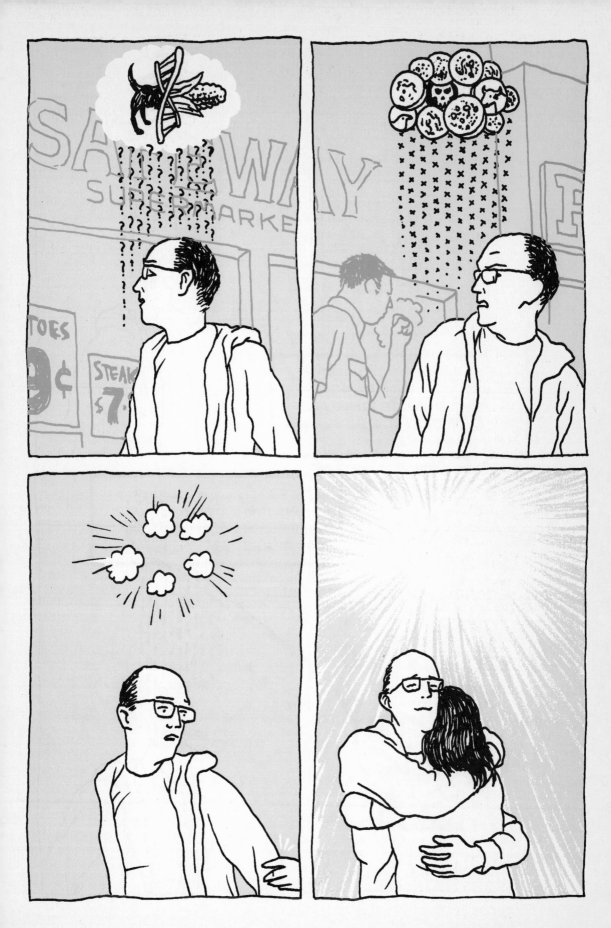

ADVANCES IN ARTIFICIAL INTELLIGENCE
AND AUTOMATIC TARGET RECOGNITION WILL
GIVE ROBOTS THE ABILITY TO HUNT DOWN
AND KILL THE ENEMY WITH LIMITED HUMAN
SUPERVISION BY 2015.

BY THE YEAR 2150, OVER 50% OF SCHOOLS
IN THE USA AND WESTERN EUROPE WILL
REQUIRE CLASSES IN DEFENDING AGAINST
ROBOT ATTACKS.

That's, what I'm waiting for

a dream

of the silent place

Last night

A

C

B

FORECASTERS

NEW YORK

ELIZABETH AMON is a journalist and writer based in Brooklyn.

RON BARRETT is an illustrator and author of *Cloudy With a Chance of Meatballs.*

R.O. BLECHMAN's most recent book is *Franklin the Fly.* www.roblechman.com

BARRY BLITT is an award-winning illustrator and funny guy. www.barryblitt.com

SEYMOUR CHWAST is founder of Push Pin Studios in New York www.pushpininc.com

RODRIGO CORRAL is a graphic designer and a has a really good mid-range jump shot. www.rodrigocorral.com

JENNIFER DANIEL is an illustrator and graphic designer in New York. www.fizkiks.com

THOMAS FUCHS is the author of *GOP100* with Felix Sockwell. www.thomasfuchs.com

JASON FULFORD is a photographer and publisher of J&L Books. www.jandlbooks.org

JOHN FULBROOK III is a graphic designer and creative director at Scribner.

CARIN GOLDBERG is a graphic designer and author of *Catalog.* www.caringoldbergdesign.com

DAVID HEATLEY is a cartoonist and illustrator and the author of the upcoming graphic memoir *My Brain is Hanging Upside Down.* www.davidheatley.com

JULIA HOFFMANN is a graphic designer. www.juliahoffmann.com

MAIRA KALMAN is an author/illustrator whose most recent book is *The Principles of Uncertainty.* www.mairakalman.com

JOON MO KANG is a graphic designer and art director of *Art Asia Pacific.* www.joonswebsite.com

KNICKERBOCKER, a.k.a. Nicholas Blechman, is an illustrator-designer and art director of the *New York Times Book Review.* www.knickerbockerdesign.com

ELIZABETH KOLBERT writes for the *New Yorker* on environmental issues and is the author of *Field Notes from a Catastrophe.*

JI LEE is art director at Droga5 and founder of *The Bubble Project.* www.pleaseenjoy.com

MARK MAREK is a cartoonist, animator, and illustrator experiencing post mid-life crisis. www.markmarek.org

BILL MARSH is a graphics editor and the publisher of a pictorial map of Philadelphia. www.marshmaps.com

RICK MEYEROWITZ's new book, *Drunk Stoned Brilliant Dead. The Writers and Artists who Made the National Lampoon so Insanely Great* will be published by Abrams.

THOMAS POROSTOCKY is the art director of *I.D.* magazine. www.porotocky.com

BRIAN REA is the art director for the Op-Ed page of the *New York Times.* He spends evenings drawing and making lists. www.brianrea.com

DAVID REINFURT is principal of O-R-G inc., cofounder of Dexter Sinister, and contributing editor to *Dot Dot Dot.* www.o-r-g.com

PAUL SAHRE is a graphic designer and educator and the author of *Leisurama Now.* www.paulsahre.com

PAULA SCHER is an artist and designer based in New York. www.paulascher.com

TAMARA SHOPSIN is an illustrator, cook, and novelty maker. www.shopsinsgeneralstore.com

FELIX SOCKWELL is a graphic designer and illustrator. www.felixsockwell.com

SCOTT STOWELL is the proprietor of Open, an independent design studio in New York City. www.notclosed.com

WARD SUTTON is a cartoonist, animator, illustrator, and author of *Sutton Impact.* www.suttonimpactstudio.com

TOM TOMORROW is a cartoonist of the syndicated strip *This Modern World.* www.thismodernworld.com

WILL VAN RODEN is a design director, teacher, and illustrator who lives in Brooklyn.

CALIFORNIA

GREG CLARKE is a regular contributor to the annual comic anthology *Blab!* www.gregclarke.com

JESSE GORDON is a filmmaker and writer, whose most recent film is *Fun on Earth.* www.lucky8prods.com

JOHN HERSEY: doodler, art school attendee, father, dog owner, and coffee addict, he devotes his time to worrying. www.hersey.com

MK MABRY is the founder of Michael Mabry Design in San Francisco. www.michaelmabry.com

MINNESOTA

ERIK T. JOHNSON is an illustrator, graphic designer, and comic book artist based in Minneapolis. www.lobrow-illustration.com

MARYLAND

POST TYPOGRAPHY is Bruce Willen + Nolen Strals, designers and band members of Double Dagger. www.posttypography.com

CANADA

CHRISTIAN NORTHEAST is an illustrator in Cobourg, Ontario.
www.christiannortheast.com

MEXICO

PETER KUPER is a cartoonist and author of *Stop Forgetting to Remember*.
www.peterkuper.com

SWITZERLAND

CYBU RICHLI is a graphic designer who lives in Lucerne.
www.cybu.ch

JULIA HASTING is the art director of Phaidon Press.
www.phaidon.com

FRANCE

JEFFREY FISHER is an Australian-born illustrator and designer living in France.
j.fisher@wanadoo.fr

GUY BILLOUT is an illustrator who lives in New York and Paris. His most recent book is *The Frog who Wanted To See the Sea*.
www.guybillout.com

UK

GEORGE HARDIE is an illustrator and design professor at the University of Brighton.

GERMANY

LUTZ WIDMAIER is the founder of Schmid-Widmaier, a graphic design firm in Munich.
www.lutzwidmaier.de

HENNING WAGENBRETH is a comic book author and poster artist who teaches at University of the Arts in Berlin.
www.wagenbreth.de

CHRISTOPH NIEMANN is an illustrator who lives in Berlin and New York. His latest book, *The Pet Dragon*, teaches Chinese characters to kids.
www.christophniemann.com

ATAK, aka Hans-Georg Barber, is an underground cartoonist and artist living in Berlin, Ghent, and Stockholm.
www.fcatak.de

NICK KULISH is the Berlin correspondent for the *New York Times* and the author of *Last One In*.
www.nydailyherald.com

SPAIN

PATRICK THOMAS lives and works in Barcelona, Spain which is suffering its worst drought in decades.
www.patrickthomas.com

FORECAST DATA

ACKNOWLEDGMENTS

Nozone is the collaborative result of many artists and designers, working off hours and between jobs, to contribute to this book. I am extremely grateful for their support, especially: Elizabeth Amon, Atak, Ron Barrett, Guy Billout, R.O. Blechman, Barry Blitt, Seymour Chwast, Greg Clarke, Rodrigo Corral, Jennifer Daniel, Jeffrey Fisher, Thomas Fuchs, John Fulbrook III, Jason Fulford, Jesse Gordon, Rob Giampietro, Carin Goldberg, George Hardie, Julia Hasting, David Heatley, John Hersey, Julia Hoffmann, Erik T. Johnson, Maira Kalman, Elizabeth Kolbert, Nick Kulish, Peter Kuper, Ji Lee, MK Mabry, Mark Marek, Bill Marsh, Rick Meyerowitz, Joon Mo Kang, Mary Jo Murphy, Christian Northeast, Christoph Niemann, Thomas Porostocky, Brian Rea, David Reinfurt, Cybu Richli, Paul Sahre, Paula Scher, Tamara Shopsin, Kevin Smith, Felix Sockwell, Scott Stowell, Ward Sutton, Tom Tomorrow, Post Typography, Patrick Thomas, Will Van Roden, Henning Wagenbreth, and Lutz Widmaier.

I am particularly grateful to Jesse Gordon for all his editorial help and guidance, and to Christoph Niemann for sharing his ideas and insights throughout this project. Thanks to Joon Mo Kang for his design wizardry; to R.O. Blechman for lending a critical eye; to Paul Sahre for his invaluable input; to Tony Cenicola for photographing the Disaster Kit; to Clare Jacobson for shepherding this book to the printer; to Erik T. Johnson for his steadfast support; to Charles S. Anderson for generously donating images from his archive; to Aviva Michaelov for getting the ball rolling; to Manar Al Muftah and Erik Brandt; to Max Blechman and Moisha Blechman for their continual inspiration. Special thanks to Luise Stauss for her suggestions, support, and love.

NOTES

Page 10: Intergovernmental Panel on Climate Change, *Climate Change 2007, Summary for Policymakers* (Valencia, Spain: 2007), section C.

Page 10: Jeff Goodel, "The Prophet of Climate Change," *Rolling Stone* 1038 (November 1, 2007).

Page 16: Wikipedia, "Water Crisis," http://en.wikipedia.org/wiki/Water_crisis (accessed February 9, 2008).

Page 20: Jeff Goodel, "The Prophet of Climate Change," *Rolling Stone* 1038 (November 1, 2007).

Page 29: International Energy Agency.

Page 29: CNN.com, http://edition.cnn.com/2007/BUSINESS/10/24/oil.decline/index.html (accessed February 9, 2008).

Page 40: Elizabeth Kolbert, "The Darkening Sea," *New Yorker* (November 20, 2006): 75.

Page 40: "Harper's Index," *Harper's* 314, no. 1882 (March 2007): 13.

Page 42: Kevin Kelley, Long Bets, http://www.longbets.org/122 (accessed February 9, 2008).

Page 42: Christophe Cauvey, Long Bets, http://www.longbets.org/78 (accessed February 9, 2008).

Page 62: John Gray, *Black Mass* (New York: Farrar Strauss and Giroux, 2007), 3.

Page 89: Associated Press, "Top Scientists Warn of Water Shortages and Disease Linked to Global Warming," *New York Times*, March 12, 2007, A11.

Page 89: Pam Belluck, "Warm Winters Upset Rhythms of Maple Sugar," *New York Times*, March 3, 2007, A1.

Page 93: George Monbiot, "Flying Into Trouble," *Nation*, May 7, 2007.

Page 93: Ibid.

Page 95: Intergovernmental Panel, *Climate Change 2007*, Section C.

Page 106: Andrew C. Revkin and Matthew L. Wald, "Solar Power Captures Imagination, Not Money," *New York Times*, July 16, 2007, A1.

Page 106: Joseph Kahn and Jim Yardely, "As China Roars Pollution Reaches Deadly Extremes," *New York Times*, August 26, 2007, A1.

Page 112: Associated Press, "Top Scientists."

Page 123: "Blinding Ourselves in Space," *New York Times*, January 21, 2007, editorial page.

Page 127: "Findings," *Harper's* 314, no. 1883 (April 2007): 108.

Page 128: Food and Agriculture Organization of the United Nations; www. mongabay.com.

Page 136: Ken Caldeira, "How to Cool the Globe," *New York Times*, October 24, 2007, A19.

Page 140: Gray, *Black Mass*, 166.

Page 162: Steve Featherstone, "The Coming Robot Army," *Harper's* 314, no. 1881 (February 2007): 43.

Page 162: Alex K. Rubin, Long Bets, http://www.longbets.org/86 (accessed February 9, 2008).

PHOTO SOURCES

Page 75-79: Photo retouching by housetribeca.com

Page 126: CSA Images, csaimages.com

Page 131: Reuters

Page 151-153: Copyright the RAND Corporation, *A Million Random Digits*, 1966, reprinted with permission.

CREDIT

Edited by Nicholas Blechman.

Designed by Knickerbocker Design and the Office of Joon Mo Kang.

Cover by Knickerbocker.

Endpapers by Christoph Niemann.

Charts on pages 10, 20, 29, 40, 42, 62, 89, 93, 95, 106, 112, 123, 127, 136, 140, 162 by Christoph Niemann.